r8-01 nw

Date Due

APR 17 '96			
FEB A00			
JUN 18 02			
AUG 22 02			

OILS
STILL LIFE

Brian and Ursula Bagnall • Astrid Hille

JACKSON COUNTY C, INC.
LIBRARY SERVICES
MEDFORD, OR 97501

Published by Walter Foster Publishing, Inc.,
23062 La Cadena Drive, Laguna Hills, CA 92653.
All rights reserved.
English translation copyright © 1994 Joshua Morris
Publishing, Inc., 355 Riverside Avenue, Westport, CT 06880.
Produced by Joshua Morris Publishing, Inc.
© 1993 by Ravensburger Buchverlag Otto Maier GmbH.
Original German title: *Stilleben, malerischer Alltag.*
Cover painting by Brian Bagnall.
Printed in Hong Kong.

ISBN: 1-56010-181-4
10 9 8 7 6 5 4 3 2

Contents

4 About This Book

6 Oil Painting—Yesterday and Today

8 Choosing Materials

10 Preparation and Getting Started

12 Mixing Oil Paints

14 Techniques of Oil Painting

16 Colors and Their Effects

18 Simplifying Your Motif and Putting It on Paper

20 Composition

22 Working with Light and Shadow

24 Summary

26 How Others Have Done It

30 Sketches

32 Painting Pears on a Cloth with Florentine Kotter

38 Painting a Still Life of a Plant with Edeltraut Klapproth

44 Painting a Set Table with Uwe Neuhaus

50 Painting a Child's Chair and an Apple with Brian Bagnall

56 Exercises, Tips, and Ideas

58 Stretching the Canvas

60 Motifs for Inspiration

62 Glossary

63 Index

About This Book

Without a doubt, oil painting is considered the classic painting medium. When people think of famous paintings and painters, oil paintings by such artists as Titian, Rembrandt, and Dalí immediately come to mind. This view of painting leads to a certain awe—not only of oil painters, but also of the medium itself. Only a select few are perceived to be capable of painting in oils. Although many people feel they could duplicate a watercolor picture, their awe of oil painting often makes them think, "I could never do anything like that"—and they never even try.

The fundamentals of how to paint in oil are what this book will provide. You will learn techniques that can eliminate the fear of "not being able to do it."

Oil is a slow medium that requires patience. Unlike watercolors, oil paints make it more difficult to achieve quick, effective results. An oil painting must be planned, and there aren't many shortcuts. Yet, oil is also a patient medium. You can change an oil painting again and again, take a short break, or even put it away for a week and come back to it.

After you've been introduced to the basics of oil painting—getting started, planning a painting, working with the paints, and developing your own style—different artists will show you, step-by-step, their personal approaches to creating still lifes. In the experiments and tips section beginning on page 58, you'll discover how much joy and freedom await you in oil painting. Have fun!

Ursula Bagnall

Ursula Bagnall is the partner of Brian Bagnall—the art director of the Artist's Workshop series—and she is responsible for the text and layout. She combines the various artists' outlooks, explanations, and paintings into a well-organized presentation.

Ursula Bagnall was born in 1945 and completed her training in graphic design at the Akademie für Graphisches Gewerbe, in Munich. Afterward, she worked with Otl Aicher on projects for the 1972 Olympic Games and later took a five-year teaching position at an American school in Amsterdam. In addition to free-lance work for Bavarian television, she has worked since 1973 as a free-lance graphic artist and author. She and her husband, Brian Bagnall, have written many books together, among them several art instruction books for children and adults.

Astrid Hille

Astrid Hille is the editor of the Artist's Workshop series and works closely with Bagnall Studios. She was born in 1955 in Hamburg, Germany, where she completed training as a technical illustrator at the Fachhochschule für Kunst und Gestaltung. She later went on to study illustration and painting. After her studies, she worked as an illustrator and painter as well as an art teacher in adult education programs. She completed a second degree in multimedia education and has been a proofreader of art books and children's books since 1985.

Brian Bagnall

Brian Bagnall shows how to paint a still life that includes an unusual combination of objects. Born in 1943 in Wakefield, England, Brian Bagnall studied painting and printmaking and completed his National Diploma with honors. He then moved to Amsterdam, where, in addition to teaching, he worked for numerous publishing houses and advertising agencies. He was also active for many years as a professor in Darmstadt, Germany.

Since 1970, Brian Bagnall has lived in Munich, where he and his wife, Ursula, opened Bagnall Studios. He has written many books, and his work has been exhibited throughout Europe and Korea.

Edeltraut Klapproth

Edeltraut Klapproth shows how much fun it can be to paint a simple motif. She grew up in the city of Dachau, home to many painters. While she was in Munich, in the 1920s, she took lessons from some well-known painters. Her artistic endeavors were interrupted by marriage and World War II, and she was not able to begin them again until her children were grown. Klapproth enjoyed surprising success at her first exhibit. Without regard for contemporary trends, she displays her work at least twice a year. She never paints a sad motif—she believes there is already enough unhappiness in the world.

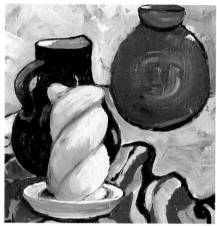

Florentine Kotter

Florentine Kotter demonstrates her unique style by showing how to paint a traditional still life. Born in 1955 in Munich, she later studied there at the Akademie der bildenden Künste, where she took master classes. Since earning her degree, she has been a successful free-lance artist and teacher of both private and high-school students. Kotter has been an instructor at the painting academy of the Münchner Bildungswerk, in Munich, since 1991.

Uwe Neuhaus

Uwe Neuhaus shows, step-by-step, how to transform motifs of glass and porcelain into a unique still life. Neuhaus was born in 1942 in Mittenwald, Germany, and studied graphic design and painting in Munich. In 1966, he opened the smallest gallery in Munich and enjoyed much success with his outlandish and unconventional paintings. He has taken part in numerous solo and group exhibitions in Germany, Italy, and Switzerland.

Oil Painting—Yesterday and Today

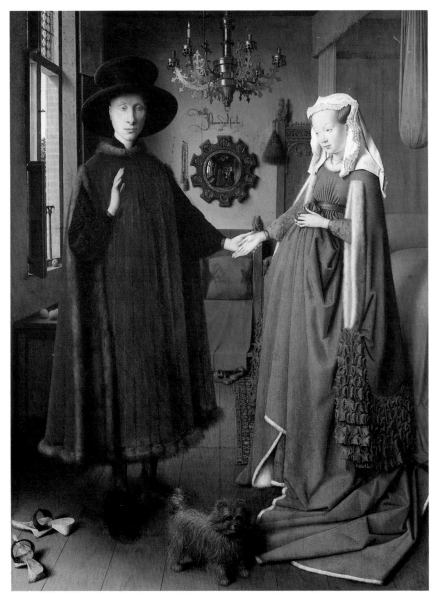

Jan van Eyck, *Marriage of Giovanni Arnolfini and Giovanna Cenami*

Anne Vallayer-Coster, *The White Soup Bowl*

The first description of the use of oil in painting appears in a twelfth-century textbook by the artist-monk Theophilus. Oil painting still had a long way to develop, however, to become the medium known today. For centuries after Theophilus's writings, artists worked with oil-based tempera paints made from resins.

Jan van Eyck (1390-1440) was long considered the originator of modern oil painting. This famous Flemish artist began to bind his earth pigments with linseed oil and a kind of turpentine. This technique opened new doors for painters. Van Eyck found that he could better control the paints' drying time, which naturally increased the amount of time he could spend working on a painting. However, Van Eyck's works cannot be considered pure oil paintings because the artist used a combination of different media, as did his predecessors. Nevertheless, Van Eyck was the first artist to build up layers of color in his paintings. He applied the base with a thin resin oil and painted over it with fat-oil temperas.

Van Eyck's ideas spread quickly. In Venice, they reached the young Titian (1477-1576), who studied them and continued to develop them. Titian went on to revolutionize painting to such an extent that art historians speak of an epoch "before Titian" and an epoch "after Titian." He went beyond the thin oil glazes Van Eyck had mastered and painted with thick, opaque layers of paint. It must have been fascinating to watch him work, as he would often put down his brush and sculpt the paint with his fingers. Titian broke away from the extravagant, almost garish color schemes of his predecessors and introduced the use of "broken colors" into painting. These are pure colors applied next to one another that combine in the eye of the viewer to create new colors. As was typical of Venetian painters at the time, he was more concerned with the overall effect of his paintings than with working out small details.

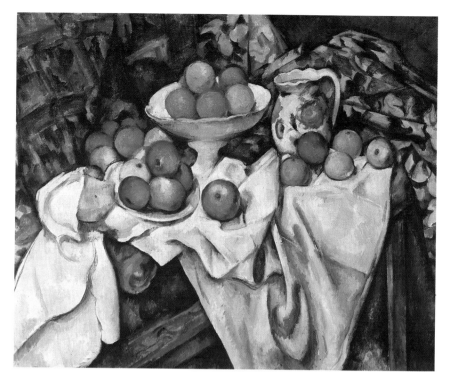

Paul Cézanne,
Still Life with Apples and Oranges

possibilities that still lifes offered. Painters had more control over their motifs: they could choose the setting, the light, and the composition. The still life became the motif of choice, as it provided scope for intensive studies of color and detail.

This way of working suited the artist Cézanne (1839-1906), who planned his paintings very carefully. The still life on this page is one of the most beautiful in a series of paintings in which he concentrated on the same theme. You can clearly recognize his use of complementary colors and warm and cool contrasts.

The Italian painter Giorgio Morandi (1890-1964) was another of the important names in modern still life painting. Although he was influenced by cubism, his work remained representational. His delicately colored still lifes radiate a fascinating simplicity and calm.

Practitioners of later styles of painting remained interested in the still life as a motif. Pop artists of the 1950s and 1960s, for example, found true art in the depiction of everyday objects. The appeal of painting still lifes in oil continues today.

By the time Titian began his work, "still life"—from the French and Italian concepts, respectively, of *nature morte* and *natura morta* ("dead nature")—already had a long tradition in painting. The depiction of motionless or lifeless objects was popular in the decorative art of late antiquity as well as in the Middle Ages, and it involved typical motifs (e.g., plants, books) or groups of motifs organized into a main theme. Starting in the Middle Ages, however, a period with a pronounced sense of allegory and symbolism, the individual objects began to take on additional meaning that supported and often explained the main theme of the painting. An iris, for example—the symbol of pain—could often be found in Christian art in paintings of Mary. The decisive step toward establishing still life as an individual genre took place during the sixteenth century.

Pure oil painting finally established itself in the seventeenth century. Also at that time, art academies began to teach still life painting as a separate subject. Technical improvements in the production of oil paints were important in both these developments and in the progress of modern painting in general. Before the 1600s, artists had to make their own oil paints, and it was not easy to produce the same colors consistently. Not until the final third of the eighteenth

century did the mass production of oil paints begin, and around 1850 the first oil paints in zinc tubes appeared on the market.

This standardization of the oil painter's palette in the mid-nineteenth century created new expressive opportunities for the Impressionists, who were concerned with the interplay of light and colors. The symbolic meaning of the objects they depicted was no longer important to artists; instead, they became concerned with the compositional and technical

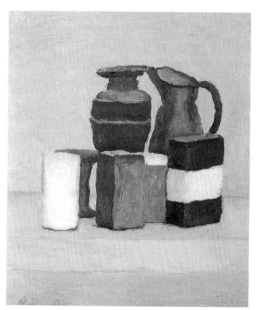

Giorgio Morandi,
Still Life

Choosing Materials

To work well, a painter must have the proper materials. It's better to pay a little more for high-quality paints, even if the greater expense limits the quantity you can buy.

The simplest approach is to buy a packaged paint set. These sets contain paints, brushes, a palette, turpentine, painting medium, and containers. It is important to make sure that the colors go together well (see pages 12 and 13). The sets have the advantage of being easy to carry; the disadvantage is that they are often more expensive than individual materials you choose yourself.

The selection of paints is one area where you shouldn't skimp on quality. Six to ten basic colors are sufficient, and you can mix them to create other hues (see pages 12 and 13).

You'll need painting medium to mix the paints and to make them dry faster. There is slow-drying, medium-drying, and fast-drying painting medium. The type you use depends on the painting you are working on and your patience.

For oil painting, the brushes should be firm and sturdy. Many oil painters prefer bristle brushes, which are available in round and flat varieties with bristles of different lengths. At first, four brushes will be enough.

Round and flat sable brushes are also available, and they are suitable for working out details. The fan-shaped brush in front of the easel below is made of sable hair and is very good for hatching and for washes (at the beginning, however, you won't need specialized brushes like this one). In general, sable brushes are more delicate than bristle brushes, and you have to clean them especially thoroughly because the fine hairs stick together easily.

In cleaning any type of brush, turpentine works just as well as brand-name brush cleaners. Washing brushes in the palm of your hand with soap and lukewarm water also works, although it is more trouble to clean them that way.

If you need to set a brush aside for a short time while you're working, you can simply put it in clean water so that it doesn't harden. You can also buy a brush holder (see the drawing on page 10). Some holders, designed especially for oil painting, have a strainer to catch the sludge produced by the paint that remains in the brushes; these holders ensure that the brushes always hang in clean turpentine or brush cleaner.

Canvas, Easels, and Other Equipment

Once you have the items to paint with, you need material to paint on—typically, canvas or paper. You can buy canvases prestretched, or you can stretch them yourself (see page 58). Pads of ready-made oil paper are also practical, albeit expensive. These pads enable you to tear the individual sheet out when you have completed a painting.

Another essential piece of equipment is a surface on which to mix the paints, or a palette. Besides using the palettes available in stores, you can blend oils on a piece of wood, plastic, or glass.

Although they are not necessary, easels are useful for painting on an upright canvas. There are small easels that can be set on a table, and larger ones that stand on the floor or ground (see also page 58).

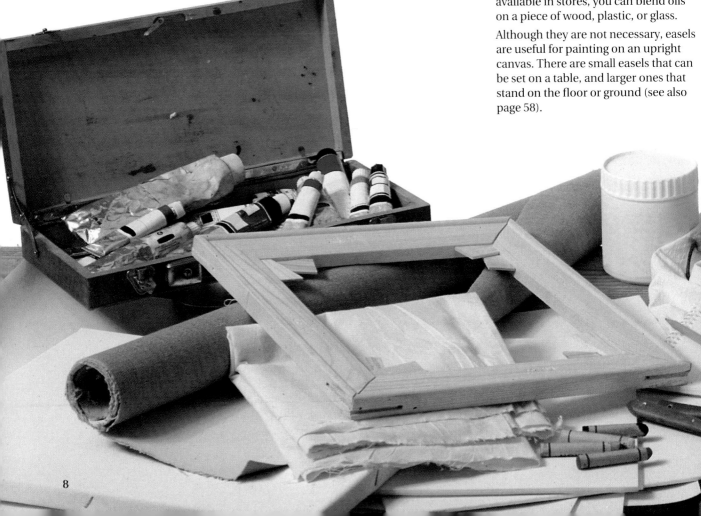

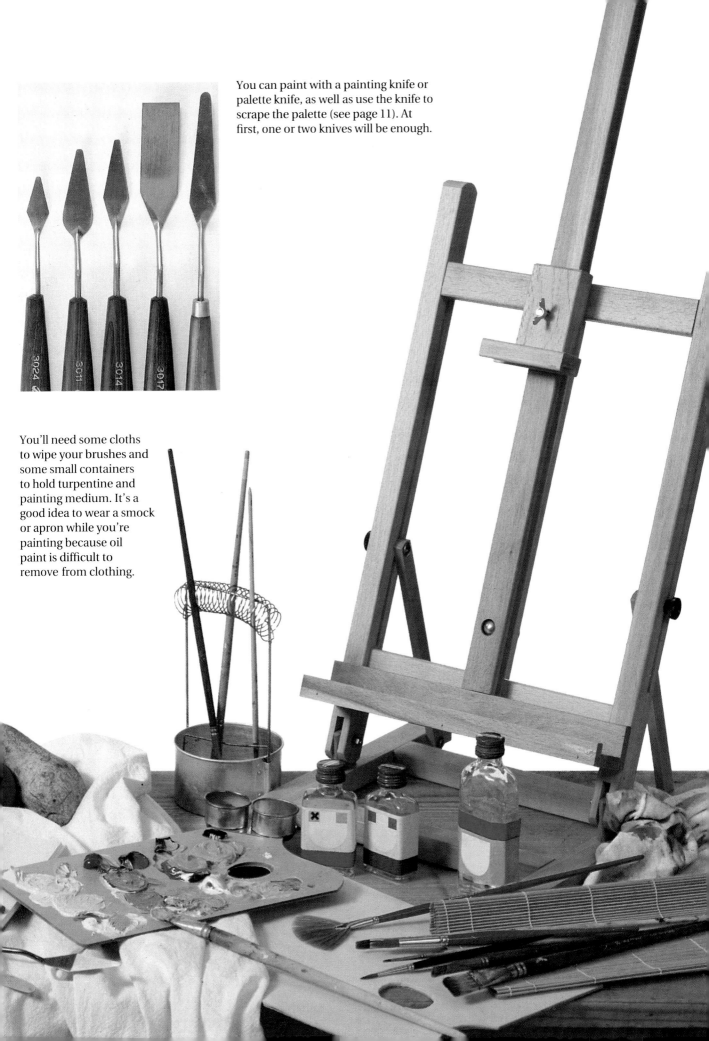

You can paint with a painting knife or palette knife, as well as use the knife to scrape the palette (see page 11). At first, one or two knives will be enough.

You'll need some cloths to wipe your brushes and some small containers to hold turpentine and painting medium. It's a good idea to wear a smock or apron while you're painting because oil paint is difficult to remove from clothing.

Preparation and Getting Started

Before you begin to paint, place your equipment within easy reach so that you won't have to interrupt your work to get something you need. You should have a comfortable seat and a good light source. Some kinds of artificial light produce a yellow effect and can give such a false impression of color that you won't recognize your painting in sunlight. For this reason, you should work in either sunlight or white artificial light.

The Painting Surface

It's easiest to paint on primed surfaces such as canvas, Masonite, or blocks of painting paper, although you can also use other solid surfaces. The main concern is that the oil paint does not soak into the material, causing ugly, oily edges around the colors. As you

Top:
Primed
cotton canvas

Left:
Unprimed
cotton canvas

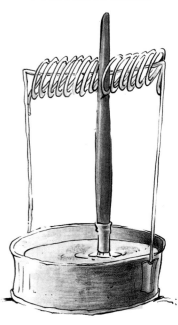

Always work with clean brushes—proper brush care will save you a lot of frustration. A brush holder that suspends the tips in turpentine is quite practical: you simply have to squeeze the turpentine out onto a cloth before you use the brushes. Never set brushes tip down in a container; the tips become bent, and then the brushes are useless.

can see in the example above, the white stands out effectively on the violet background. The artist mixed the paints with fast-drying painting medium and applied it to cardboard.

When you want to work with unusual formats, you can have relatively inexpensive cotton or linen canvases made in art supply stores. Making these canvases yourself is a lot of work,

but if such a project interests you, you'll find some tips beginning on page 58. Untreated canvas, which soaks up a lot of paint, should be primed with a white primer called gesso. Gesso can be applied thick and textured or thin and smooth, depending on the absorbency of the surface.

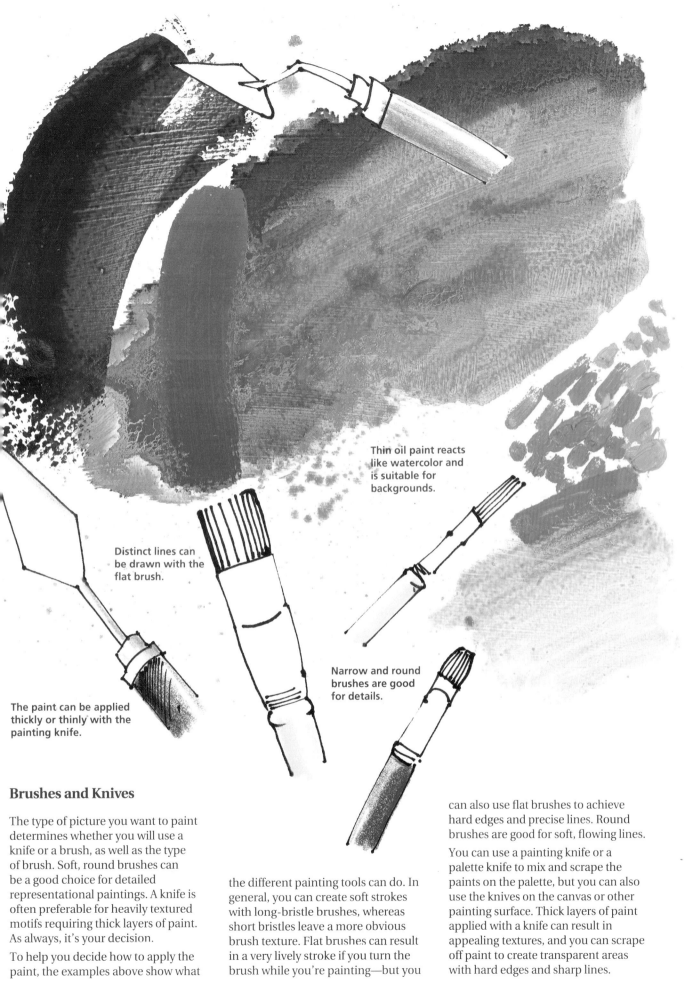

Thin oil paint reacts like watercolor and is suitable for backgrounds.

Distinct lines can be drawn with the flat brush.

The paint can be applied thickly or thinly with the painting knife.

Narrow and round brushes are good for details.

Brushes and Knives

The type of picture you want to paint determines whether you will use a knife or a brush, as well as the type of brush. Soft, round brushes can be a good choice for detailed representational paintings. A knife is often preferable for heavily textured motifs requiring thick layers of paint. As always, it's your decision.

To help you decide how to apply the paint, the examples above show what the different painting tools can do. In general, you can create soft strokes with long-bristle brushes, whereas short bristles leave a more obvious brush texture. Flat brushes can result in a very lively stroke if you turn the brush while you're painting—but you can also use flat brushes to achieve hard edges and precise lines. Round brushes are good for soft, flowing lines.

You can use a painting knife or a palette knife to mix and scrape the paints on the palette, but you can also use the knives on the canvas or other painting surface. Thick layers of paint applied with a knife can result in appealing textures, and you can scrape off paint to create transparent areas with hard edges and sharp lines.

11

Mixing Oil Paints

There are limitless ways to apply oil paints: thick or thin, smooth or textured. Mixing the paints is a good exercise to become acquainted with the many possibilities the oil medium offers. At first, you'll need a basic palette of colors that go together well.

(Note: The projects in this book call for a much greater variety of colors.)

Approximately 8 to 12 colors are enough to mix many other hues. You should have a warm and a cool version of each primary color (see pages 16 and 17): for example, cadmium red and alizarin crimson, cadmium yellow and lemon yellow, ultramarine blue and cerulean blue, and yellow ochre and burnt umber.

You'll also need chromium oxide green, titanium white, ivory black, and, possibly, gold ochre.

In general, you should sacrifice quantity for quality when you buy paint. Individual tubes are better than prepackaged sets of paints because the latter may not contain the colors you need.

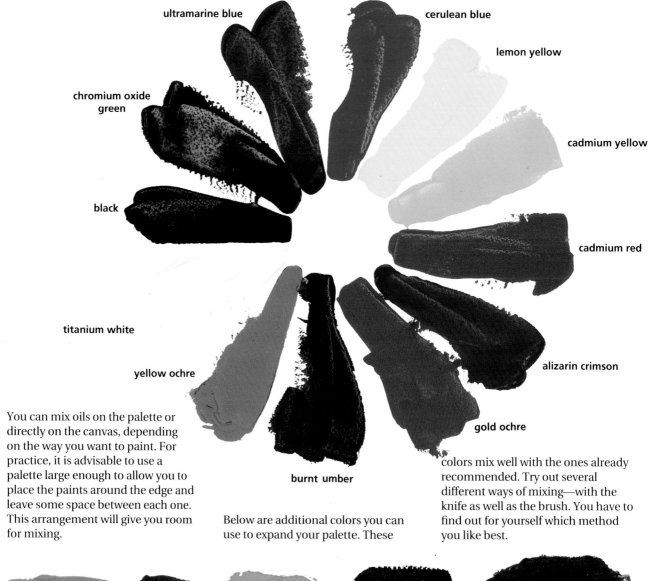

You can mix oils on the palette or directly on the canvas, depending on the way you want to paint. For practice, it is advisable to use a palette large enough to allow you to place the paints around the edge and leave some space between each one. This arrangement will give you room for mixing.

Below are additional colors you can use to expand your palette. These colors mix well with the ones already recommended. Try out several different ways of mixing—with the knife as well as the brush. You have to find out for yourself which method you like best.

chrome orange burnt sienna cadmium green light Prussian blue magenta

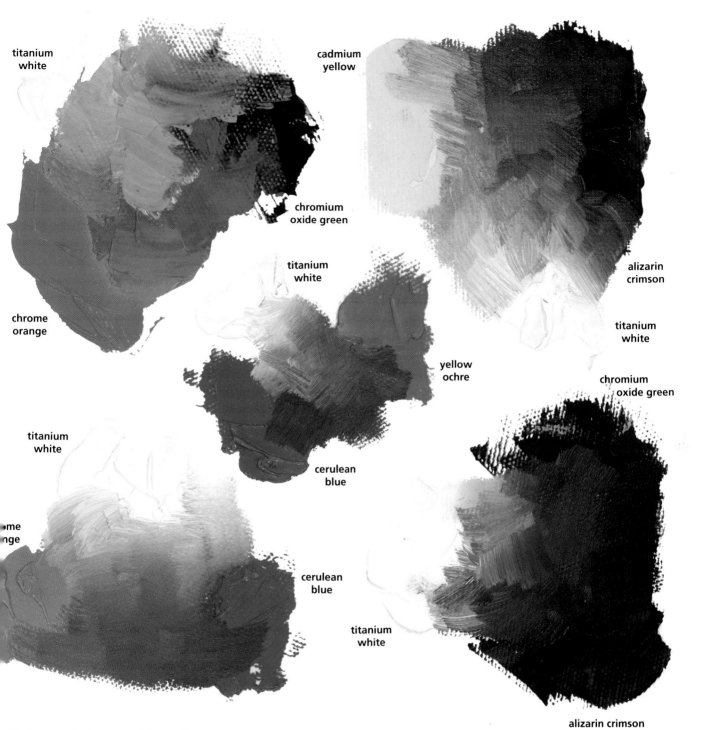

titanium
white

cadmium
yellow

chromium
oxide green

alizarin
crimson

chrome
orange

titanium
white

yellow
ochre

titanium
white

titanium
white

chromium
oxide green

cerulean
blue

me
nge

cerulean
blue

titanium
white

titanium
white

alizarin crimson

Each example above combines only white and two colors. You can see that these mixtures result in a remarkable number of hues—even grays. Titanium white is recommended for both mixing and painting because it covers better than zinc white or flake white and is not as poisonous. When you mix oils, wipe your brush on a cloth after using each color so you don't produce unwanted mixtures.

In the example at the right, the artist mixed three primary colors with black and white, which resulted in unusual grays.

cadmium yellow

cadmium red

cerulean blue

titanium white

black

13

Techniques of Oil Painting

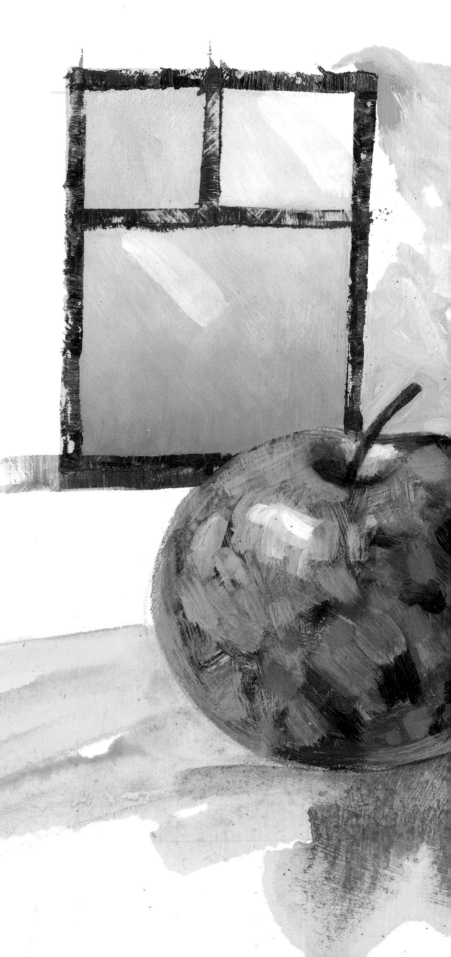

You've probably already seen different oil painting techniques. The old masters produced oil paintings that have an astonishing amount of detail, and some modern painters seem to have applied the paint by the pound. The only way to find out which techniques you're most comfortable with is to experiment.

One of the fundamental characteristics of oil paints is that they keep a long time—which also means that they take a long time to dry. The colors on your palette are not wasted if you run out of time for painting before you use up all the paints. You can continue to use them after several days and sometimes even after several weeks.

Oil paints dry slowest when you use them straight from the tube. You can thin them with linseed oil, turpentine, or painting medium, which accelerates the drying time. Linseed oil and turpentine make the paints dry more quickly, too, but not to the same extent as painting medium.

Applying Glazes

A glaze is a thin layer of paint that allows the background to shimmer through; this background can be the canvas itself or a color that has already been applied. If you don't want the background color to mix with the glaze, you have to make sure the background is completely dry.

You can see the glazing technique very clearly in the example to the right: the artist thinned the paints so much that they look like watercolors.

Painting Gradations

In the painting of the window above, you can see a gradation from dark blue to light blue. To achieve a gradation, start with the dark color and gradually add white to it (or gradually add color to the white). The transition from one value to another can be smooth, with even brush strokes from top to bottom (or bottom to top), or it can be heavily textured, as it is here.

Using the Palette Knife and the Painting Knife

The palette knife and the painting knife are especially good for applying thick layers of paint or creating heavy textures. You can spread the colors smoothly, but you can also produce hard edges, as in the window frame in this painting.

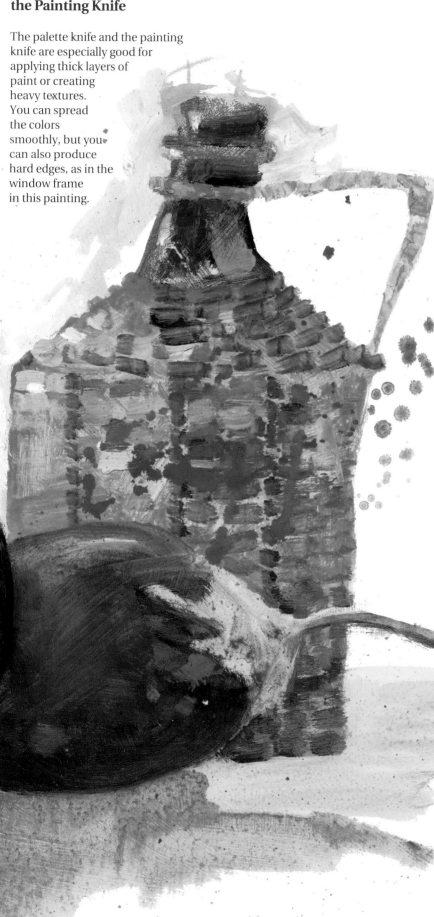

Working Wet-in-Wet

If you apply fresh oil paint to wet paint that is already on the canvas, both paints will blend. In contrast to watercolors, however, oil paints blended in this way do not result in particularly surprising effects because the paint doesn't run.

The apple and the eggplant in this picture were painted wet-in-wet. The artist painted the apple with distinct brush strokes and set the colors next to one another. The colors of the eggplant, however, were mixed on the canvas and blended together.

Working Wet-on-Dry

You can create interesting textures by applying thin layers of color to a dry background, as the artist did here on the bottleneck. The dry brush stroke lets the background shimmer through, creating a textured line or area.

Using Impasto

The technique of applying thick layers of paint is called impasto, which is illustrated by the wine bottle in this painting. You can apply the paints so thickly that you can feel the texture when you touch the picture with your hand. A palette knife or stiff brush is the best tool for this technique. Work with short, choppy movements that leave the paint sticking up from the surface. Depending on the thickness of the paints, the drying time can be very long.

Here's a tip: Because of its oil content, fresh paint doesn't "stand up" from the surface very well. First apply the paint to a cloth to soak up the excess oil, and then use the stiff paint that results.

Colors and Their Effects

Before concentrating on composition and expression, you need to consider the effects of colors. The colors, as well as the motif, tell something about a painting. Colors create moods. Some colors seem cold, and others have a warm, cozy effect. A few even seem aggressive, whereas others are calming. Psychologists make use of the effects of colors, drawing conclusions about their patients on the basis of color preferences or dislikes.

The distinction between warm and cool colors originates from different experiences with objects and the environment. Ice, snow, and deep, cold water often appear blue, so blue has become associated with cold. Fire and the sun contain reds, which observers associate with warmth. Of course, not all colors can be classified easily. Red-violet and yellow-green, for example, are neutral.

Red doesn't always have to be warm, however, and blue doesn't always have to be cool. There are warm blues and cool reds, the degree of warmth or coolness depending on the amount of red or blue in the respective color. In general, a red with a large amount of blue has a cool effect, and a blue with a large amount of red has a warm effect.

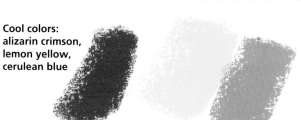

Cool colors: alizarin crimson, lemon yellow, cerulean blue

Warm colors: cadmium red, cadmium yellow, ultramarine blue

In general, when painters describe a color, they refer to the hue—for example, red or green. If they characterize the red as light red or dark red, they're talking about its value. The value is the darkness or lightness of a color.

The pictures below were painted with the same colors: cadmium red light, cadmium yellow light, cerulean blue, alizarin crimson, and burnt umber. The colors of the lighter picture were lightened with titanium white. The colors of the darker picture were darkened with ivory black. The hues, however, remain the same: the red-yellow of the apple on a green-yellow surface.

In addition to appearing warm or cool, colors can seem happy or sad, fresh or tired, soft or bold. Here the artist chose a motif—a brush and a pencil—that by itself doesn't convey any particular mood. Yet the picture to the right has a bright, cheerful effect conveyed by the brilliant, friendly colors. In contrast, the effect of the painting below is heavier: the dark background and the subdued colors create a gloomy effect in spite of the light highlights.

Try to create moods using colors only, with no motif. How would you depict, for example, a summer day or a winter day?

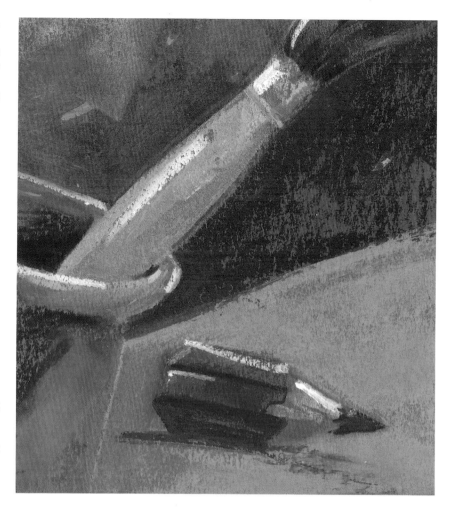

Below is an illustration of the flickering effect, which can be lively but disturbing as well. When two colors with the same intensity are placed next to one another, they seem to flicker. This often happens with primary colors, such as red and blue, or with complementary colors, such as red and green. Famous pop artists intentionally used this effect. If it occurs in one of your paintings, however, you may find it unsettling. If so, try lightening one of the colors with white or darkening it with black.

Simplifying Your Motif and Putting It on Paper

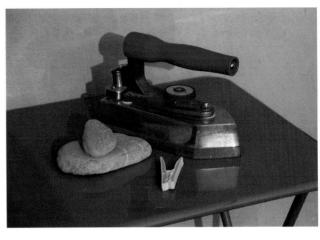

To be able to transfer a motif to paper or canvas, you have to simplify it first. Simplifying a motif means deciding from the beginning which details are necessary and which can be left out. If you're painting a bouquet, for example, you can't paint each individual leaf and petal; you have to limit yourself to the most important elements. You can reduce many objects to basic shapes, such as the circle, the square, and the triangle. Think of a round apple, a square closet, or a triangular hat.

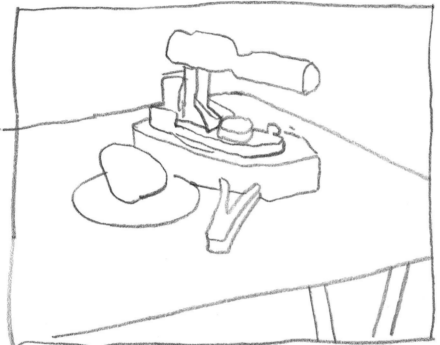

When you begin to paint a simple still life, highlights and textures are unimportant. Everything can be transformed into simple linear shapes. A good exercise is to sketch a common object and leave out the unnecessary details. The design on a cup, for example, is not as important as its shape.

You should form your motif as you see it. This means that you can change, exaggerate, or even leave out portions of it. In the photo above, the artist saw too much empty space but liked the shapes formed by the legs of the table. As you can see in the sketches, the iron has been enlarged and the surface of the table made smaller, reducing the appearance of emptiness. The artist's composition is more balanced, with no change in the motif.

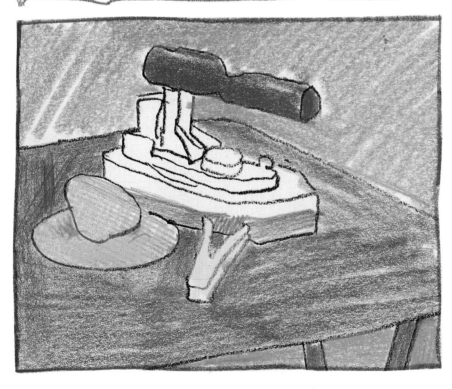

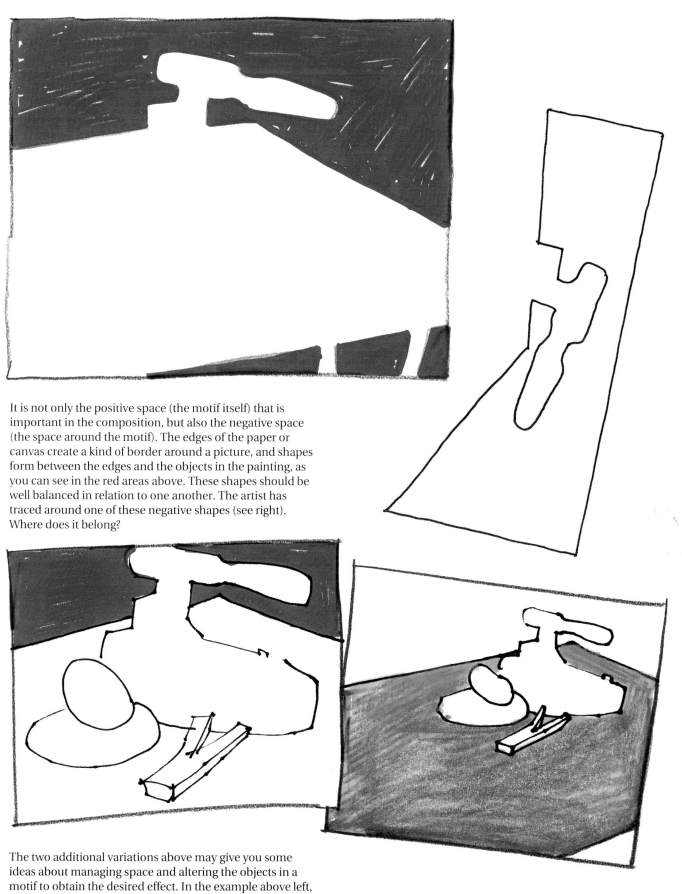

It is not only the positive space (the motif itself) that is important in the composition, but also the negative space (the space around the motif). The edges of the paper or canvas create a kind of border around a picture, and shapes form between the edges and the objects in the painting, as you can see in the red areas above. These shapes should be well balanced in relation to one another. The artist has traced around one of these negative shapes (see right). Where does it belong?

The two additional variations above may give you some ideas about managing space and altering the objects in a motif to obtain the desired effect. In the example above left, the artist has enlarged the objects. The surface of the table becomes unimportant, and the negative space is emphasized by the red background. In the example above right, the surface of the table is the most important element, and the objects are secondary.

For practice, find a photo with a simple motif, turn it upside down, and draw it. You'll be surprised at how good your sketch is. When you stop looking at an object "correctly," you automatically balance positive and negative space.

Composition

A composition is an arrangement that has been thought out. Composing can involve arranging objects in a room, arranging flowers in a vase, or setting a table. Planning a composition is especially important in painting because the composition can determine whether a picture is boring or interesting; you also have to arrange the elements of the motif to achieve the illusion of three-dimensionality on a flat surface. The distribution of space, the background and foreground, and the focal points must all be carefully planned.

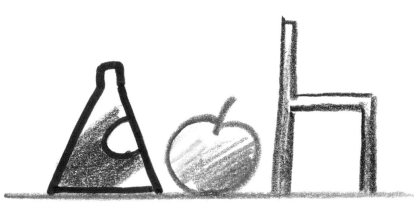

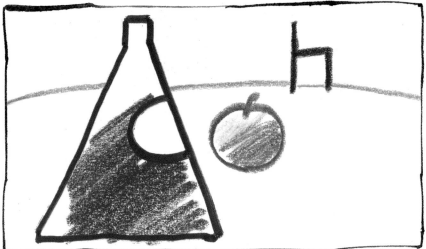

Consider the three objects above—a bottle, an apple, and a chair—as an illustration. When you simply place them next to one another, the composition merely says, "Here are three objects standing next to one another." As soon as you change the objects' sizes, however, and add a horizontal line, the picture gains a foreground, a background, and expression. Moreover, a relationship develops among the objects: the bottle, for example, is large—larger than the chair—and seems closer than the other objects. Still, everything seems isolated and spread out.

By overlapping, you can effectively achieve a feeling of depth. The apple, which is cut off by the edge of the picture, is larger than the chair and appears closer than both the chair and the bottle. The chair, drawn small and also cut off by the edge, appears to be at the other end of the imaginary room. The apple is important for the expression of the painting, whereas the chair is secondary.

Try a few sketches like this yourself. You can use the same objects or different ones (e.g., a vase, a pear, and a cup), but they shouldn't be complicated. Experiment with overlapping and with varying the sizes of the objects to bring different focal points into the composition.

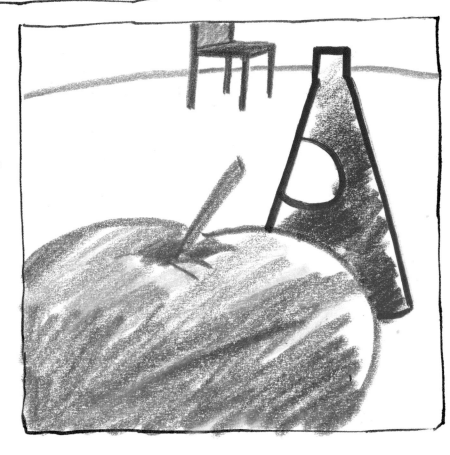

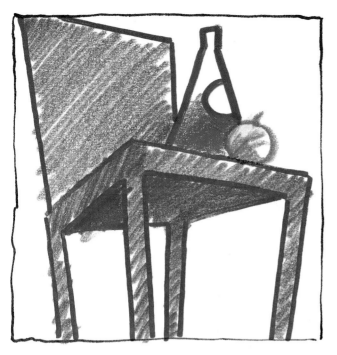

These four examples show how the expressive element of a painting can change with the composition. The chair above is all the way in the foreground of the sketch and is very large. It's cut off by the edge and gives the impression of closeness.

The large empty space suggests distance and leads the eye to the comparatively small objects. Now the chair and bottle are so distant that they don't entirely fit within the edges of the picture. The apple overlaps the bottle, not because of its size but because it has been placed in front of the bottle.

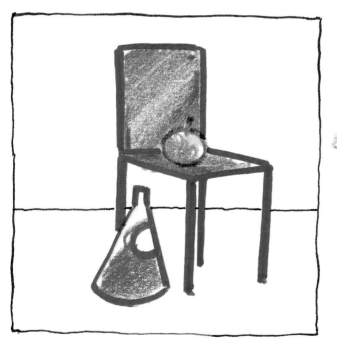

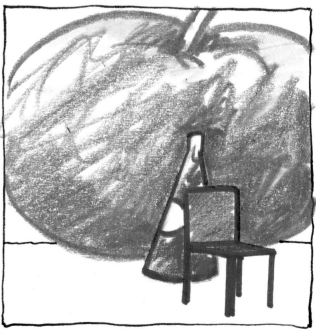

Everything is in order in the sketch above. The chair in the center is in the right proportion to the apple and the bottle. As in the case of most symmetrical compositions, this balance conveys the impression of tranquility.

Here, however, the tranquility is gone. The apple almost bursts out of the room, the bottle is absurdly larger than the chair, and the diagonal layout, as usual, creates tension. Exaggerations and diagonal layouts are good techniques to make a composition livelier.

Working with Light and Shadow

You now know something about transferring shapes and distributing space, but the objects themselves still need to be considered. You can capture the external shape of an object relatively quickly, but giving the object depth and three-dimensionality is more difficult. You have to understand light and shadow, which are easiest to see in an example.

The apple without shadows (below left) is simply a circle with a stem. As soon as you give it shadows (center), it takes on shape. The shadow on the object itself is called the core shadow.

The shape of the apple is clear in the center sketch, but no one can tell whether the apple is floating, falling, or resting firmly on a surface. The cast

shadow gives the viewer this information. In this example, the cast shadow is thrown onto the surface by the light behind the apple. A cast shadow is almost always darker than a core shadow because the core shadow is illuminated by reflected light.

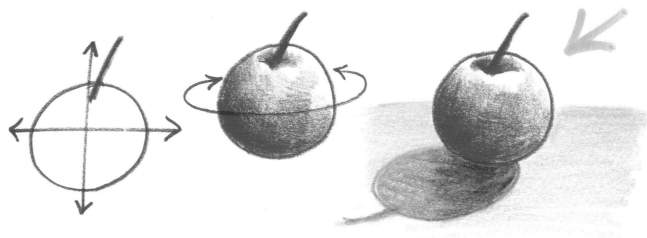

The shape and length of the cast shadow depend on the position of the light source. The lower the light source is, the longer the shadow. The sun at midday, for example, is high in the sky, and shadows are very short and centered closely around objects.

Look at the examples below from left to right. The light in the left-hand

example is coming from the upper left, and the shadow is only slightly distorted. In the middle example, the light is directly overhead, and the shadow encircles the cup. In the right-hand example, the light source is low, and the shadow corresponds in direction and length.

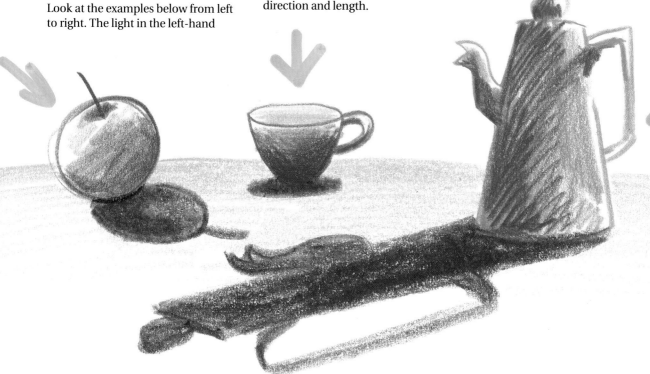

When light shines on several objects, their cast shadows form one shape, as you can see in the painting at the right. Unfortunately, no steadfast rule exists to help painters figure out what colors are in a shadow. Of course, the shadow is darker than the object itself, so the core shadow can be added by darkening the color that was used in painting the object. However, no shadow is made up of a single color: the colors of the surroundings are reflected in it as well. The cast shadow, for example, is affected by the surface it is cast on, as well as by other objects. You can paint a violet shadow cast by a red vase onto a blue tablecloth, but there are other possibilities. Carefully observe shadows and use your imagination. Look closely at the shadows in the example at the right. They consist of many different colors.

If you want to concentrate further on light and shadow, a good exercise is to take a simple object and set it in front of a light source that you can easily change—for example, a desk lamp. Sketch the shadows that result when the light source is placed in different positions. Experiment with unusual positions, and continue to sketch the variations in the shadows.

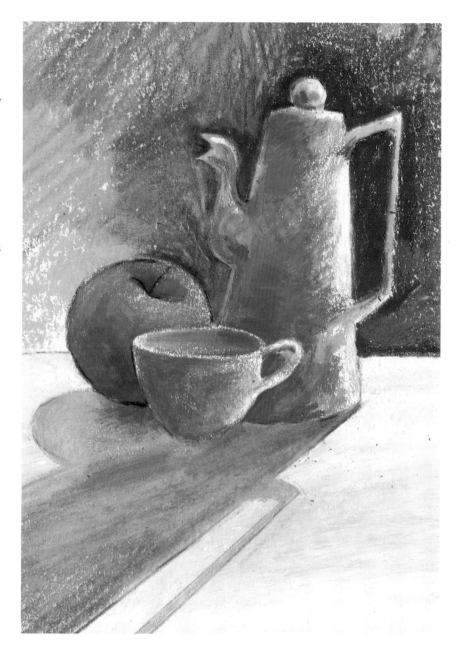

What happens when there's no discernible light source? Of course, there's always a light source unless it's pitch dark, but often it's difficult to tell exactly where the light is coming from.

Moreover, often there's no distinct shadow. As you've learned, however, shadows are needed to give an object form and position. The simplest solution is to suggest a cast shadow.

A small, dark area suffices, and it doesn't have to be distinct. If the light is diffused, the shadow is correspondingly scattered.

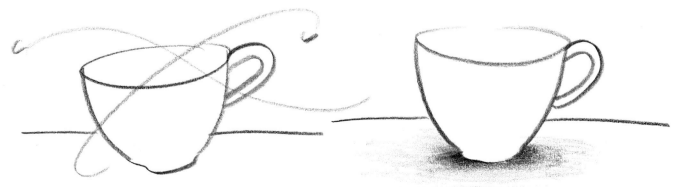

Without a shadow, it's difficult to tell where this cup is resting. Even a slight shadow helps give the cup position.

Summary

Now you're ready to look at all the elements of a finished painting.

The painter of the still life on page 25 plans compositions very carefully by first sketching out the spatial relationships, the shadows, and the focal points, as you can see in the example sketch at the right. Oil pastels have been used for the sketches here because they are similar to oil paints. The painter begins by sketching the basic shapes of the matchbox and the vase to decide on the objects' exact positions and to determine the shadows. Several sketches are made so that all the different possibilities can be considered. Not until the final sketch, for example, does the artist exaggerate the match to give the impression of depth and to avoid having to reduce the size of the vase and flowers.

The shadows, which seem almost to have an independent life, and the interplay of positive and negative space are important to the artist in this still life. The flowers behind the matchbox are unusual, and the matchbox itself is smaller in reality than it is in the painting. The flowers and the vase become a unit, but they give the impression of depth, and they catch the eye.

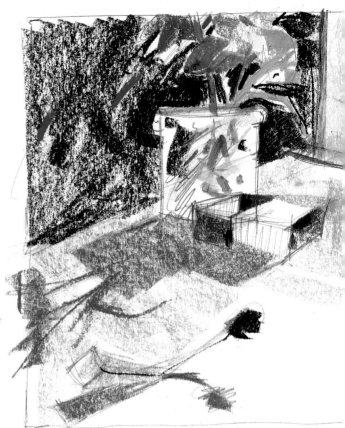

The large area of negative space (clearly visible in the left-hand sketch) plays a very important role. All the colors of the foreground are reflected therein. The artist intentionally uses the small shapes between the flowers to add interest.

Tension and liveliness result from the obvious diagonal layout from the lower left to the upper right. The shadows of the vase and flowers, as well as the surface of the table, lead the eye into the background.

Drawing a box is a good exercise to become familiar with light and shadow because the box's three-dimensionality depends on them. Make sketches of a small box from several angles and under different light sources. Matchboxes are especially good for this exercise because you can pull out the inner box to produce all kinds of shapes and shadows.

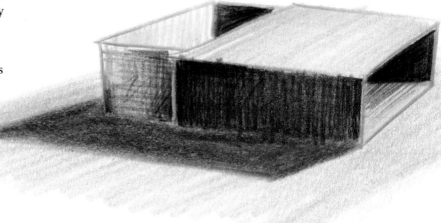

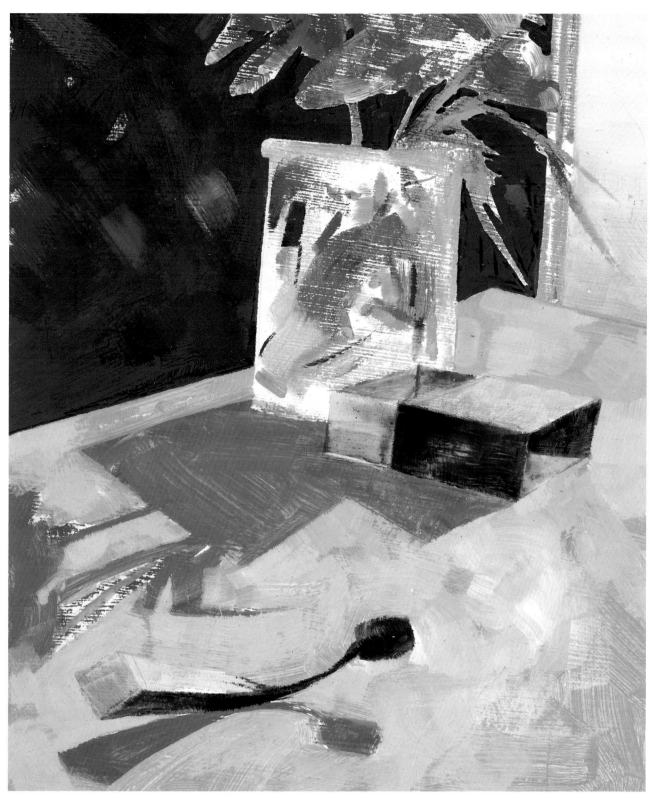

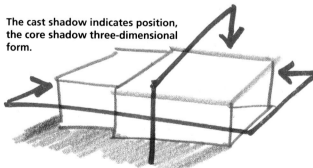

The cast shadow indicates position, the core shadow three-dimensional form.

Avoid covering surfaces with a single color. Oil paints are especially good for creating lively areas of color in which the colors of other objects are reflected. Look at a wall—it is not simply one color. Better yet, perform a brief experiment: Look at a bright light and then at a smooth, single-color surface. You'll find that the surface no longer appears to be one color; you see spots and different shades.

How Others Have Done It

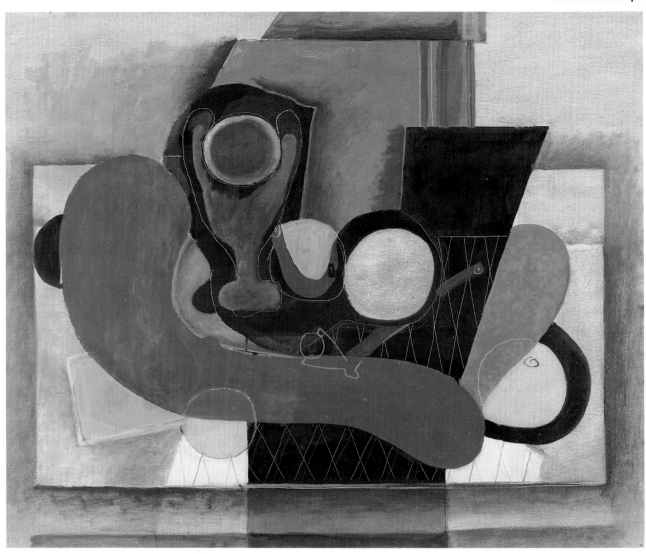

Georges Braque
1882-1963

Copying famous painters can be both an interesting exercise and an inspiration. It's more a matter of discovering how these painters worked than of creating an exact replica of a famous painting.

In this still life by Georges Braque, a French painter and friend of Picasso, the viewer finds very simple, nearly graphical shapes. Braque was quite adept at using colors that appear almost to be monotones, and the interplay of smooth and textured surfaces is especially interesting here. Braque intentionally scratched into the paint to create texture; a somewhat exaggerated example of this technique appears at the left. Braque's shapes are simplified to the point of abstraction, but the objects are still recognizable.

Smooth areas combined with textured areas provide contrast.

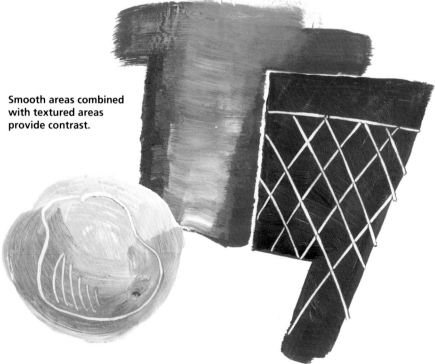

Vincent van Gogh
1853-1890

Even people who know little about art can easily recognize the work of Van Gogh. The many thick, colorful strokes of paint that seem to bring movement to any motif are typical of the work of this Dutch painter. The clear colors, which he applied next to and on top of one another, are mixed by the eye into one hue, although the colors themselves contain many nuances.

Look more closely at a chair leg from the painting *Chair and Pipe*. The leg is built up from a base coat of dark green. Many painters of Van Gogh's time added blue edges to achieve greater three-dimensionality, like the ones you can see in this detail. The cool blue recedes into the background while the warm yellow and orange come to the foreground.

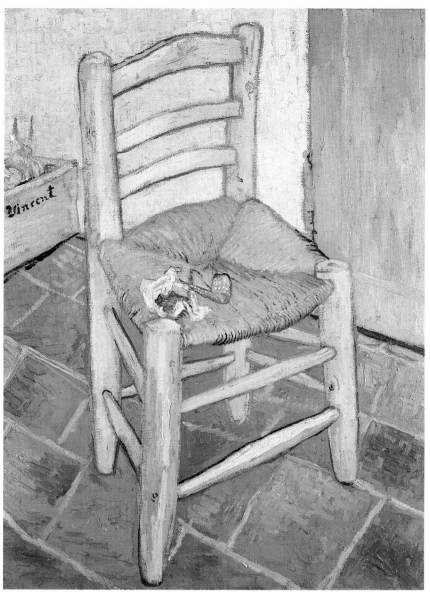

Vincent van Gogh,
Chair and Pipe

The two examples below show the way the textured areas are created. The floor tiles are shown at the left; the wall in the background is shown at the right. The first coats of paint are applied thinly, and they gradually become thicker.

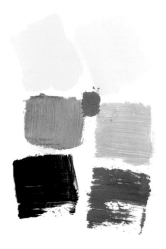

Giorgio Morandi
1890-1964

The Italian painter Giorgio Morandi liked to paint everyday objects. He painted still lifes of bottles, vases, and other containers. In the painting at the left, he limited himself to a palette of cool colors. The only warm color—and thus the focal point of the painting—is the orange. He used these colors either in pure form or mixed with white.

Giorgio Morandi, *Still Life*

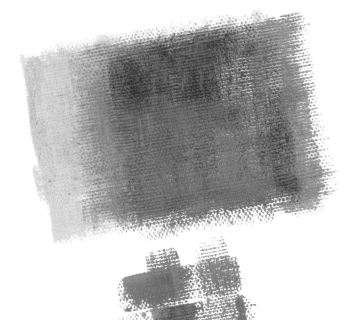

The composition, which is simplified in the sketch below, contradicts everything taught in art classes. All the objects are the same size and lumped together in the center of the picture. Moreover, the relatively large areas around the objects become very obvious. In spite of these features, however, the painting is not boring because the dark shadows provide contrast and the small orange area draws the eye toward it.

Notice the liveliness of all the areas of the painting. Morandi didn't simply mix a gray for the foreground, for example; he worked his way up to it. The center illustration demonstrates how he did this. First yellow is applied on a heavily textured surface, then blue is painted over it. You can see this effect in the green areas. The next layer is a mixture of black and blue, topped with a final layer of blue mixed with white. The paints are kept rather dry.

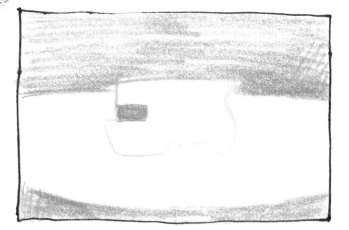

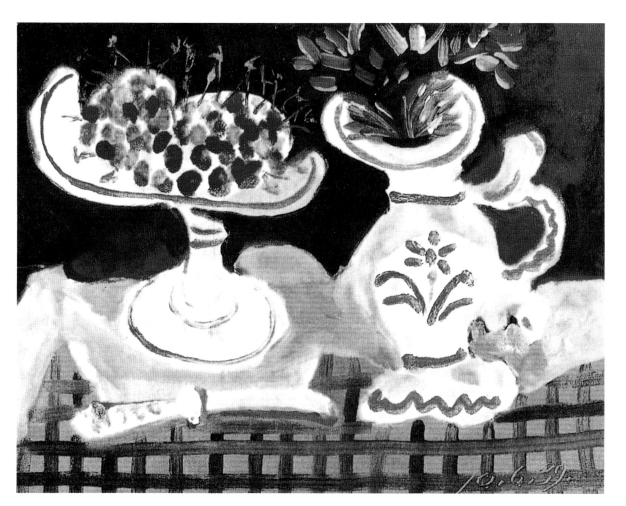

Pablo Picasso
1881-1973

Picasso was a spontaneous man who didn't pay much attention to convention. He worked quickly, and you can feel this rapidity in his paintings. In his *Pitcher and Fruit Bowl,* he decided on a composition similar to Morandi's, which most teachers would discourage: two objects of almost equal size standing in the middle of the painting. However, the colors and liveliness negate any trace of monotony in this painting. Picasso applied the brush strokes spontaneously, simply dabbing the paint to create the cherries in the bowl. He treated the negative space as intensively as the positive space, and he wasn't concerned with exact perspective.

Pablo Picasso,
Pitcher and Fruit Bowl

Even spontaneous lines can be artistic.

Picasso didn't wait around for his paint to dry. When he drew in the lines, the colors blended, which created very interesting effects.

29

Sketches

Sketches are basically quick studies. They allow artists to observe and preserve objects, settings, or events they have seen. Sketches can be records of vacation memories, studies of faces or poses, details of buildings, or landscape compositions. Frequent sketching will train you to transfer your motifs to paper, to simplify, and to concentrate on the important aspects of a motif. It's a good idea to make a lot of sketches in your spare time or while you are on vacation. In this way, you can assemble a large supply of motifs for later use.

Sketches can be changed and combined, and the finished painting may contain only the basic idea developed through sketching. The appeal of a sketch lies in its spontaneity. There is no pressure to create a finished composition, as you don't have to hang a sketch on the wall—although you can.

In the past, sketches were always a preliminary step for a painting. They were never considered art by themselves. This attitude has changed today, however, and there isn't necessarily a definite boundary between a sketch and a finished picture.

Sketches are essential in oil painting. An oil painting has to be planned, and many artists create several preliminary sketches—some in color—before they begin the actual painting. Some even do several watercolor paintings and then transfer these preparatory efforts to a work in oil.

Some artists like to use oil pastels for sketches because they simulate oil paints. The pastels enable painters to try out color combinations and different mixtures. Other artists prefer to use colored pencils or felt markers to experiment with compositions and color schemes.

Here you can see several sketches in oil pastel. This artist likes to work on colored paper because it simulates a coated surface. A photograph of a textured surface has been glued onto the paper to add interest to the sketch of the green pepper (immediately above).

An artist discovered unusual compositions at breakfast and captured them with felt markers.

Another painter creates collages of magazine photos, such as the collage above. The pears on the background of oil pastel appear almost to be painted. You can get interesting ideas for paintings in this way. All the sketches here can give you ideas for your own oil paintings.

Painting Pears on a Cloth

with Florentine Kotter

Are you searching for motifs? Look around. Your surroundings offer many possibilities. If you like to observe and if you're open to impressions and influences, you'll always be able to find ideas for a painting. It's not important to make an exact reproduction of what you see in nature. It's more interesting to express yourself in a painting—to change, simplify, and exaggerate.

Here I develop the motif of fruit on a table. This may seem simple, but it actually requires some thought and several preliminary sketches. I often create many sketches to become familiar with the way I want to build my painting. Let's look first at the folds in the cloth—a classical theme in itself. Folds come to life through light and shadow, and the different shapes become more distinct. It's a good idea to squint your eyes when you look at folds and to capture the dark and light values in small sketches.

At first, I place half an avocado together with the pear because I think the combination is effective in terms of colors and shapes. After a few charcoal sketches, however, I come to the conclusion that the pears look better by themselves.

I always study the objects very closely so that later I can work freely with colors and shapes. Here, for example, I add folds where, in reality, there aren't any.

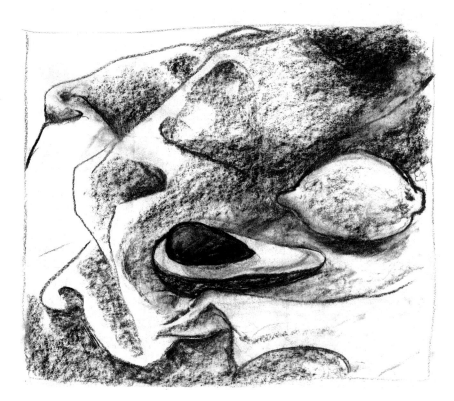

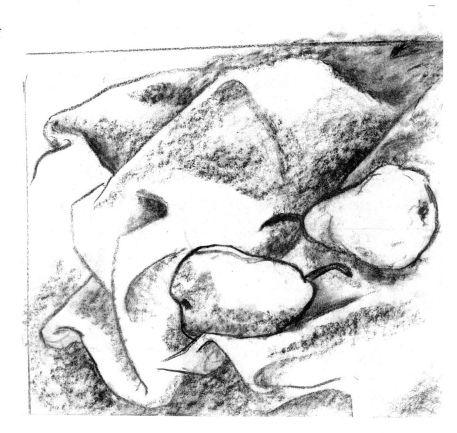

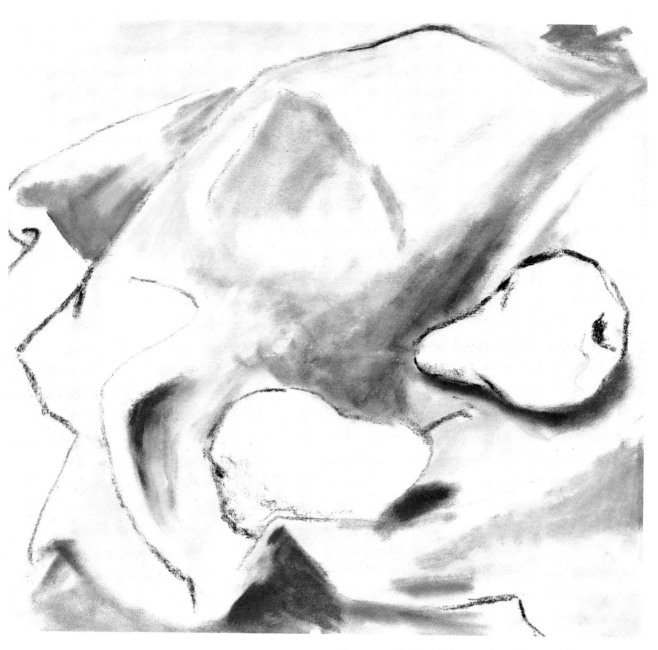

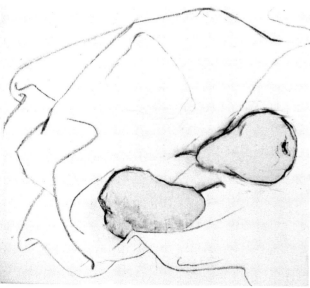

First I roughly sketch the motif on the primed canvas (see the example at the left). Then I determine where the pears will be, where the cloth will bunch, and approximately where to place most of the folds. When I rough in a painting, I don't follow my sketches exactly—the canvas sometimes inspires me to a completely different composition.

Next I work on the folds, that is, with the light and shadow. For this I use a "dirty" white—titanium white mixed with other colors, such as Prussian blue, brilliant yellow, or black. The cast shadow thrown by the pears onto the cloth has to be darker than the shadows of the folds; the pears' shadow helps show the flow of the material. It doesn't bother me if the charcoal smears and mixes with the paint—you won't be able to see the smudging or mixing when the painting is finished.

You can already see that the focal point of the painting is in the lower right section.

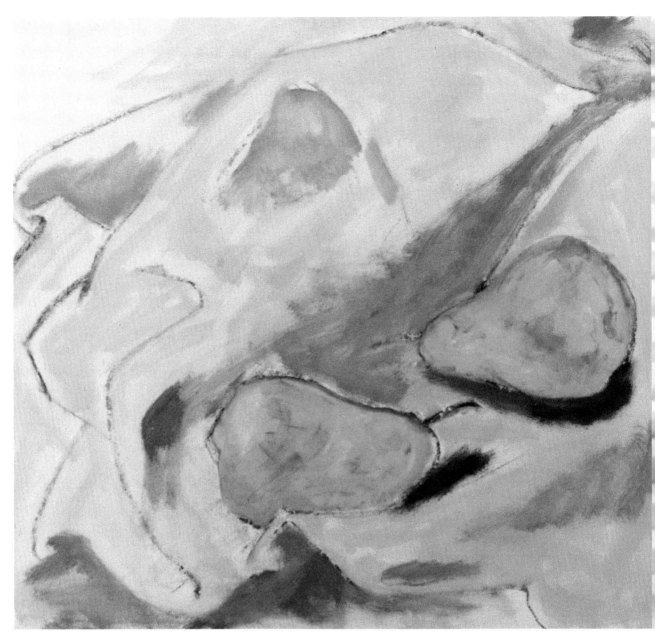

Colors used:

titanium white, ivory black, brilliant yellow, lemon yellow, cadmium red, burnt umber, Prussian blue, ultramarine blue

Next I intensify the colors: I begin this process by applying the yellows, using a mixture of cadmium red and burnt umber in the pears. At this point, it isn't important to me whether the folds actually look like folds; I think of them more as abstract elements surrounding the pears. The basic lines of the composition form a strong diagonal layout that leads the eye from the lower left to the upper right, interrupted by the horizontal fruits and softened by the other shapes of the folds.

I take a lot of time to paint a picture because I continually allow myself to be inspired by colors and shapes and because I don't pursue a predetermined goal. I combine intense

observation of an object with the idiosyncrasies of the medium. Moreover, I don't try to control the medium completely—I let it influence me as well. At this stage, I work with glazes; the first layers of color should shimmer through.

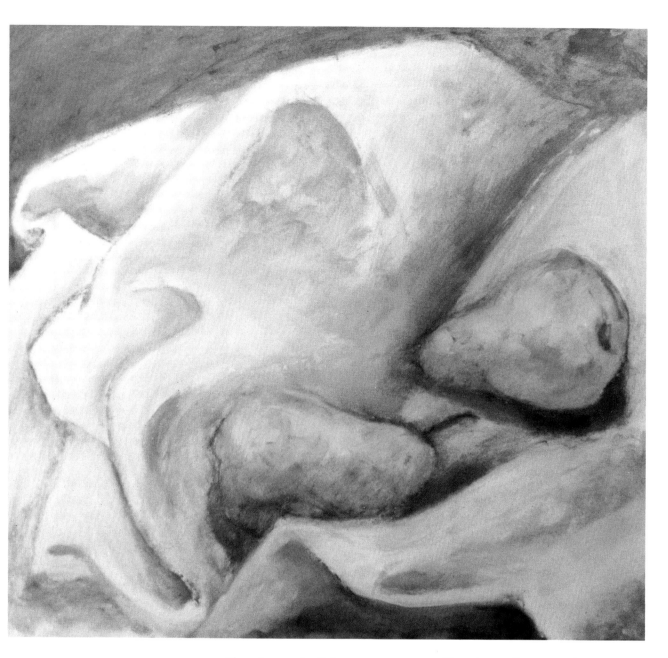

The colors gradually become more dramatic and intense. I go over the folds with Prussian blue and ultramarine blue, and I also apply a little umber and yellow. To emphasize the folds, I lay in a dark background to provide contrast to the white. Incidentally, the cloth is white, but it gets some color from both the shadows and its own surroundings, an effect I exaggerate in my painting.

An important aspect that holds the composition together is the repetition of the hues throughout the painting. A touch of yellow, for example, appears in the cloth as well as in the background—although, in reality, only the pears are yellow. Always try to add color to smooth, single-color surfaces.

Even the smallest areas of your painting should be planned and consciously modeled; don't neglect them for the sake of the main motif.

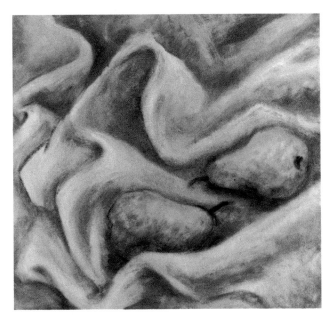

Variations

During the painting process, changes in the composition and color scheme frequently occur. I'd like to show you a few of them here, beginning with the picture above.

The background, which at first I find necessary as a contrast, begins to bother me because it is too dominant. I decide to add more folds instead, and thus bring more and livelier shapes into the painting. Now nothing detracts from the pears—they are the most important element in the painting.

Is this variation too boring? Should I add a completely different shape to the still life?

A bowl, with its soft, round shape, may be a good choice. First I place the bowl on different parts of the table before adding it to my painting. I don't want it to be too near in the foreground, but I also don't want it to appear to be part of the cloth. This solution doesn't completely satisfy me.

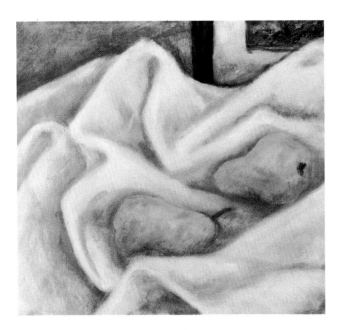

I add a dark background after all—the canvas is patient. Of course, sometimes there's a lot of time between sessions at my easel, and the paint can start to dry.

In this variation, I place clear, graphic shapes against the folds—a picture in a frame. I also work more on the folds themselves by intensifying the colors and simplifying the shapes. Nevertheless, this frame distracts too much from the fruit.

In a situation like this, there's only one thing left to do to help me decide where I want to go: I reduce everything to whites and grays to make the shapes stand out clearly. When I do this, I find that I like the simplified folds in the foreground, and the pears nestle attractively into the cloth. Of course, I let the colors underneath shimmer through the white. They provide a kind of orientation for me when I begin to work with stronger colors again.

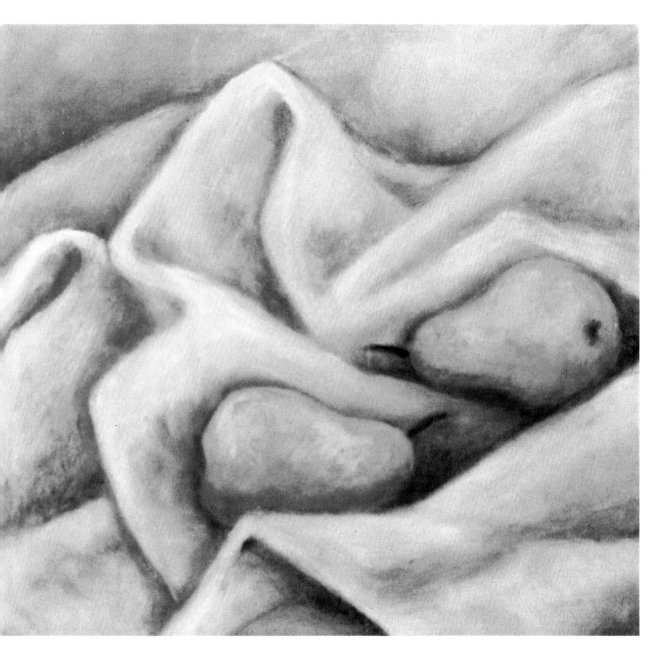

After all these experiments, I finally figure out the way I want my painting to look, so I return to color. In some spots, I simply wipe off the white, and I don't mind if some is left behind. Then I intensify colors and shapes, put in shadows, and emphasize light areas. Now the cloth looks soft and fluffy, and the pears grab the viewer's eye.

At this point, I think the painting is finished. Someday, however, I may want to go back and change something, and the advantage of oils is that I can make a change anytime. In spite of this flexibility, though, I recommend that you begin a new project rather than work too long on the same painting, especially if you

don't have much experience with oils. When you spend too much time on a painting, you may find that you lose sight of what you like and dislike.

Painting a Still Life of a Plant

with Edeltraut Klapproth

For me, the right working environment is just as important as the proper materials. I keep everything I need within easy reach so I can concentrate on my painting. I buy my canvas prestretched and preprimed. The white surface bothers me when I start a painting, though, so I apply a very thin coat of a neutral color as a base. By using this technique, I avoid becoming committed to a specific color scheme.

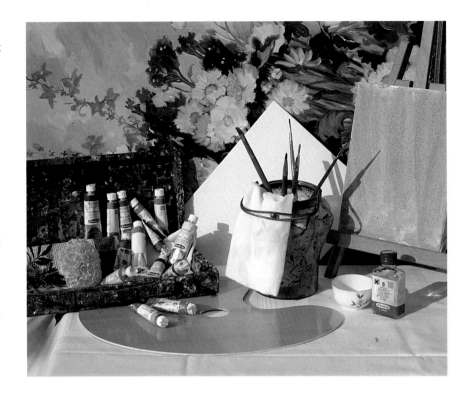

I reserve special brushes for the most important areas in my composition—a wide brush for large areas and a fine one for details. All my brushes are made of sable hair. While I'm working, and, of course, when I've finished, I wash them thoroughly with turpentine so I don't get unwanted mixtures and blotches on my paintings.

I pour small amounts of slow-drying painting medium into a cup, which I cover when I take a break. I prefer slow-drying medium because I like to let the colors blend, a difficult effect to achieve with fast-drying medium. I also have a cloth handy to soak up excess paint or to remove clumps of paint.

My painting determines which colors I put on my palette, and I make sure there's enough space between them so they don't mix. I prefer to use fewer colors but to choose high-quality ones.

It takes time to arrange the objects for a still life, and I try out many different combinations. I move the objects around until I like the composition. For the painting described here, I decide on a potted plant with a candle and fruit. I make a few sketches of the final arrangement, and I use the best sketch for the oil painting.

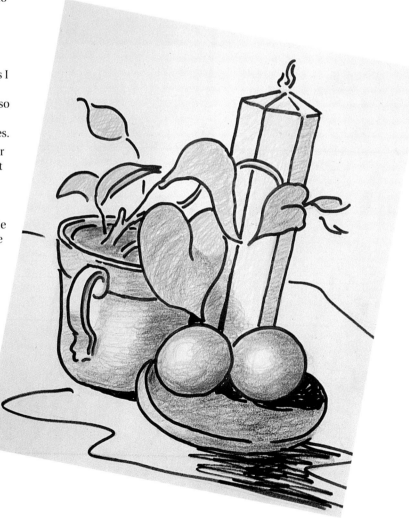

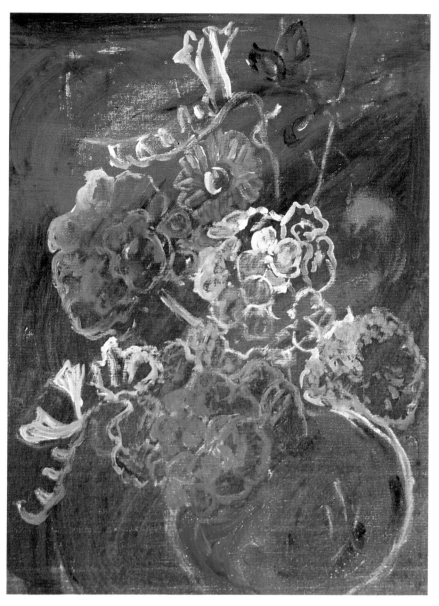

Every artist has a favorite way of sketching out the painting. I don't like to use charcoal on the canvas because it can smear and muddy the paints. Instead, I use thinned oil paint to sketch in the composition roughly, a process that requires a certain amount of drawing ability. A painter also needs a good eye to transfer the proportions of the sketch accurately to the canvas. I don't recommend using a grid to transfer the motif because it stifles creativity and spontaneity.

As you can see at the left, this colorful sketch has a certain appeal of its own. I work out a strong, colorful background and lay in the flowers in white. When I begin a painting in this way, it inspires me to use my imagination.

How would you finish this painting?

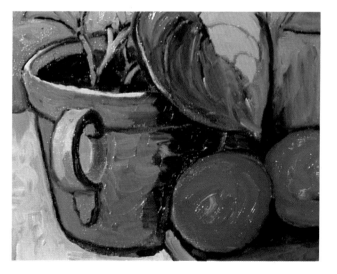

A perspective line drawing shows three-dimensionality and space. In a painting, however, strokes and lines can be unappealing, so you have to create three-dimensionality and space using light and shadow and other techniques.

You can see obvious differences between these two pictures. The edge and the handle on the pot directly above have a highlight, which, contrasted with the darker colors, gives them three-dimensionality. Compare the two smaller pictures here, and then look back at pages 22 and 23.

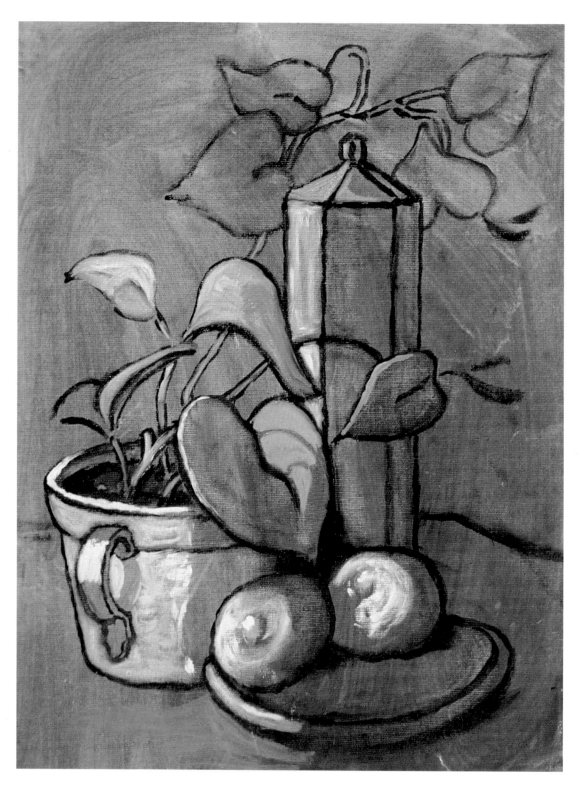

The composition actually begins with choosing and arranging a motif. When you arrange a still life, pay particular attention to shadows, overlapping lines, and negative space. Unwanted shapes that form between objects can be very distracting. I make sketches as I go along to get a feel for the way my painting will look. It doesn't have to be a reproduction of reality. If, for example, I want a leaf to overlap the smooth shape of the candle, I add the overlapping, even if it doesn't exist among the objects themselves. After all, the plant provides plenty of examples of the way a leaf actually looks.

After I paint the contours, I put in the light and dark areas.

Colors used:

violet, lemon yellow, cadmium yellow deep, cadmium red, cobalt blue, burnt sienna, burnt umber, yellow ochre, olive green, Hooker's green, titanium white, black

I can change things on the canvas, and I can add or remove objects. With practice, you get a feel for what you can exaggerate and what you can reduce. Diagonal lines add liveliness, so I let the plant flow from the lower left to the upper right. Next I put in the reds and greens, and I paint the pot and soil with ochre and brown. The painting gradually begins to acquire three-dimensionality.

I work out the shadows and emphasize the shapes. I also reduce the highlights on the red fruit—I can always increase the light later if I think it's necessary. More important to me are the round-ness of the fruit and the relationship of the fruit to the large leaf.

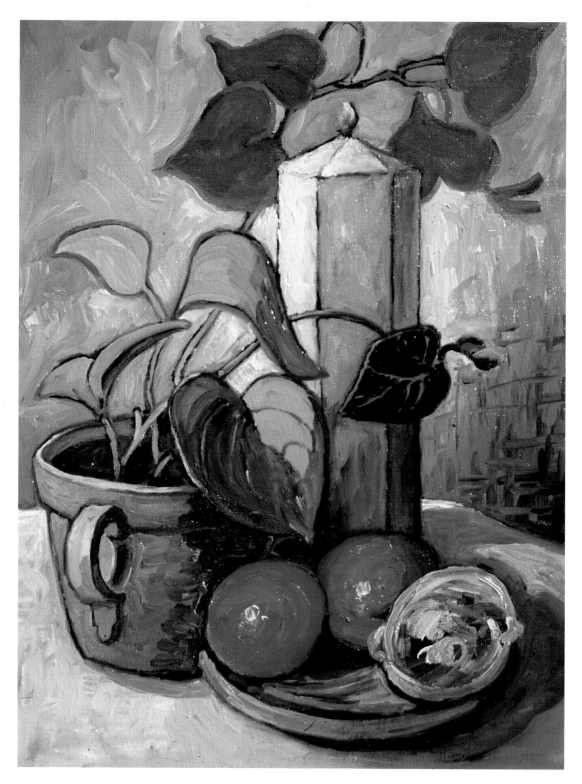

Now I think it is finally time to start working on the background, which plays an important role because it can make or break the motif. It's not always easy to decide which colors to use.

I often try out a few colors in different spots in the painting that I can paint over later if I don't like the result. The background shouldn't be dead and boring. Because an effective background is lively and in harmony with the rest of the picture, avoid painting the areas around your motif in a single color. I've found that the background can even express my own mood, which I experience again when I look at a painting years later.

Often while I'm painting, I step back from the picture and look at it from a distance. In this way, I can quickly tell if anything's missing. When I step back from the painting I'm describing here, I find that I need something to balance the yellow of the candle—to counteract its dominance. The solution: a yellow lemon. I lay it in with a few strokes, satisfied that it will reestablish the balance of the painting.

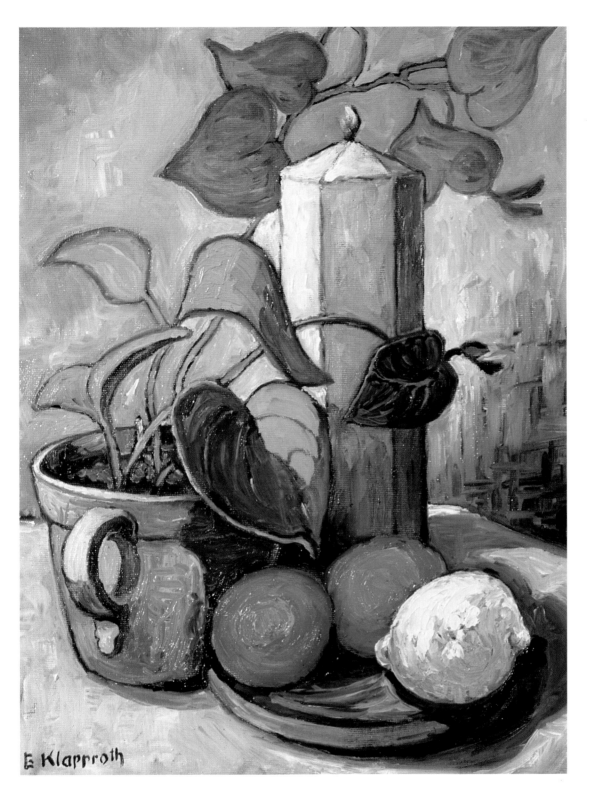

E. Klapproth

The last step consists primarily of polishing the details. I still have to make the lemon three-dimensional, and the white highlights on the red fruit bother me because they distract the eye too much from the rest of the painting.

I paint over these highlights again, as well as smooth out the background, emphasize the shadows, and lighten some elements and darken others.

After looking more closely, I decide that the red is too isolated—it looks almost like a foreign object in the painting. To incorporate the red more into the overall composition, I repeat it in the soil.

Next comes the most difficult part: stopping. It's always difficult to decide whether your painting is finished, but, unfortunately, you have to make this decision for yourself. Sometimes a

little more work can be too much; sometimes, however, that "little bit more" can be the finishing touch.

I decide to stop. My painting is finished.

Painting a Set Table

with Uwe Neuhaus

I've always been fascinated by old, handblown glasses. I collect them, and I've painted them on occasion. There's always something about them that isn't quite smooth or perfect, and that's what gives them their charm.

When you paint glasses like these, it's often difficult to achieve the effect of transparency. Before I begin to paint, I study the highlights, curves, and shadows of the glass in different lighting situations.

I like to sketch on packing paper. Because it's expendable and because it's not "serious," this kind of paper gives me the freedom to try out anything.

I often write notes around the edge of the sketch. Sometimes I like the result so much that I frame the sketch and hang it on the wall.

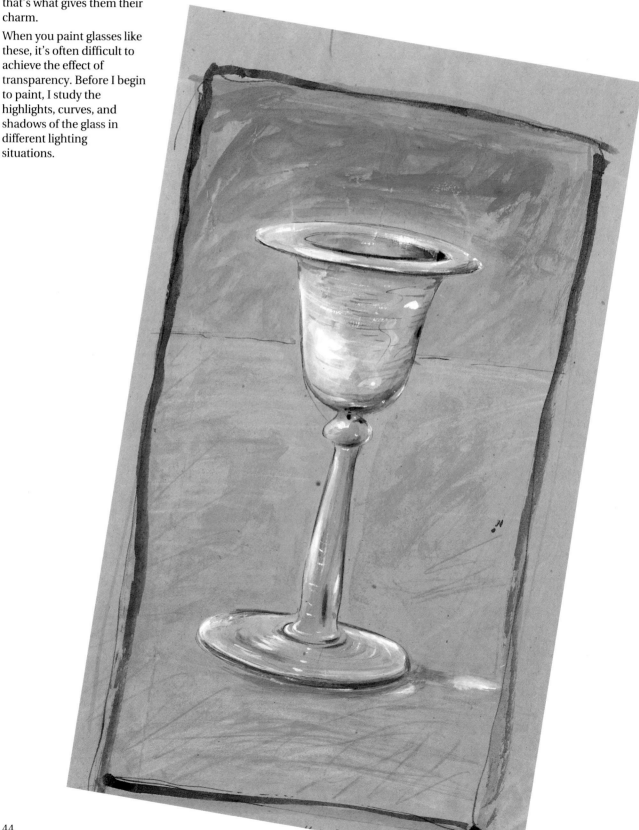

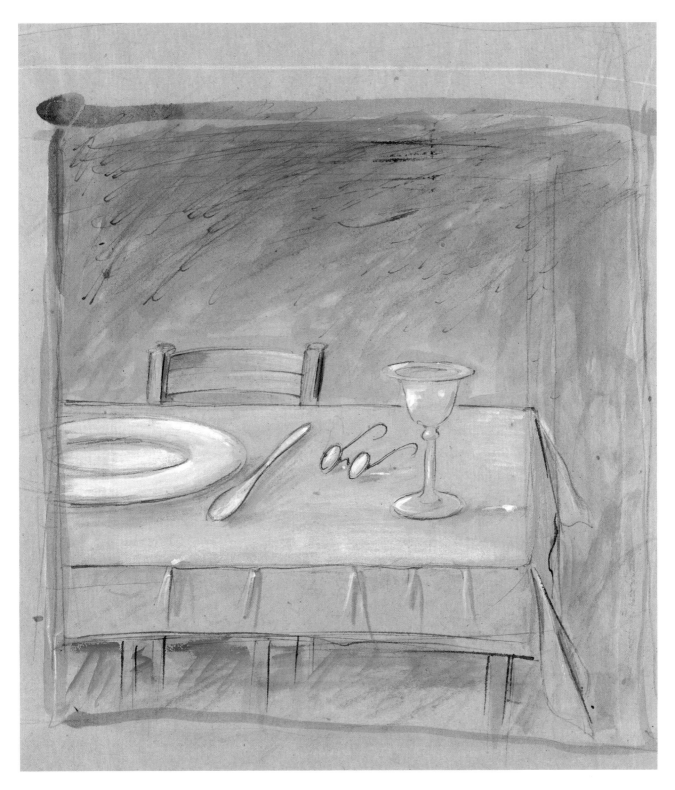

The glass by itself isn't enough, so I set the table—albeit sparsely. I try out several different compositions, adding a book, then a bowl—but I finally take everything away. Why not add just a plate, some silverware, and a chair that can be seen only partially?

I try out a few unobtrusive colors. Of course, the colors look different on the packing paper than they do on the white canvas, but when I'm sketching, my ideas are more important than the picture I'm going to create. I form a rough draft, but I want to remain open to any ideas that might occur to me along the way.

After I make a few sketches, I decide on the following colors: titanium white, violet, olive green, chromium oxide green, cadmium red light, yellow ochre, turquoise green, cobalt blue, and English red.

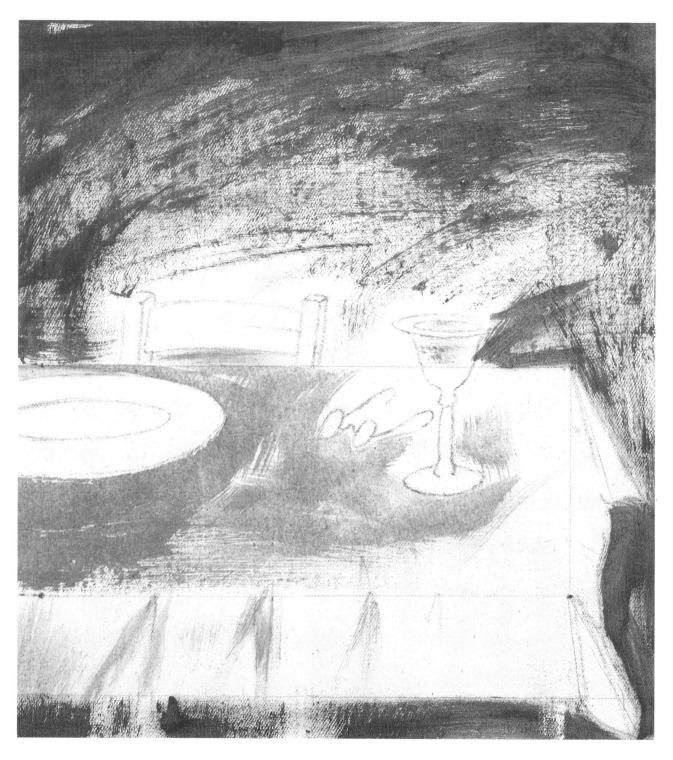

Prestretched, preprimed canvases don't always meet my needs. Any firm surface is suitable for oil painting (except plastic, of course) if it is primed properly. I like to paint on wood and then incorporate the grain into the painting.

In this example, I stretch tightly woven cotton across a board with thumbtacks and go over the cotton with gesso. I can take this canvas off the board when I've finished with the painting and handle it as I would paper. I can cut the painting out, crop it, or even leave the thumbtacks in and frame the whole thing.

When the gesso is dry, I sketch in the most important contours of my still life with a soft pencil. Then I apply the first colors: the background of cadmium red and the tablecloth of thinned cobalt blue.

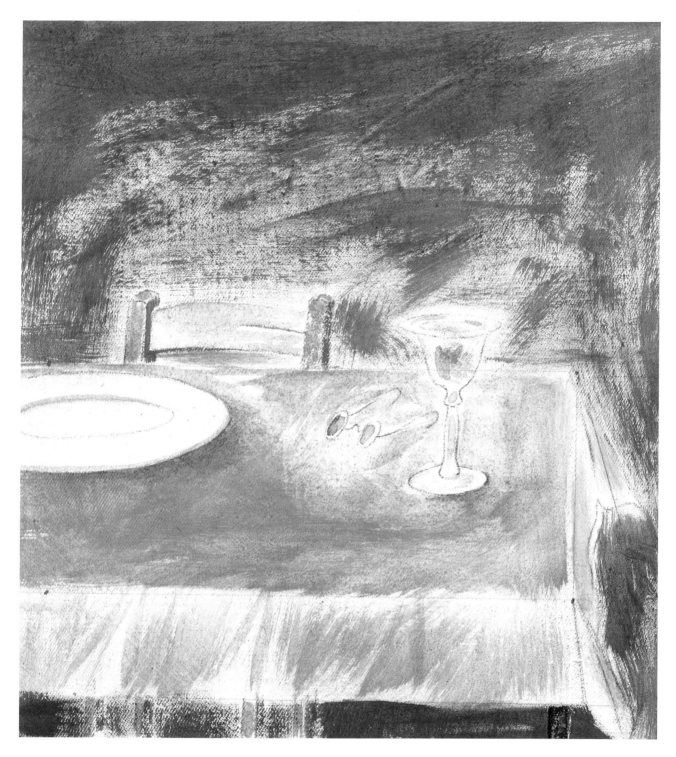

The first shadows give a hint of three-dimensionality; the light is coming from the left. I apply the first glaze to the back of the chair to give it some form, and I put in the table legs. At first glance, the table legs seem unimportant, but they are actually an essential element of the composition because they divide the lower half of the painting into several rectangular shapes.

Although it's not necessary in oil painting, I prefer to allow the white of the canvas to show through. This method of working makes me concentrate on the shapes and helps me remember where the light areas should be.

Several blue and red flecks made up of the same colors as the tablecloth and the background give the glass its transparency. All of a sudden, I am struck by the monotony of the color scheme, and I add some pink (a mixture of white and English red) to the eyeglasses.

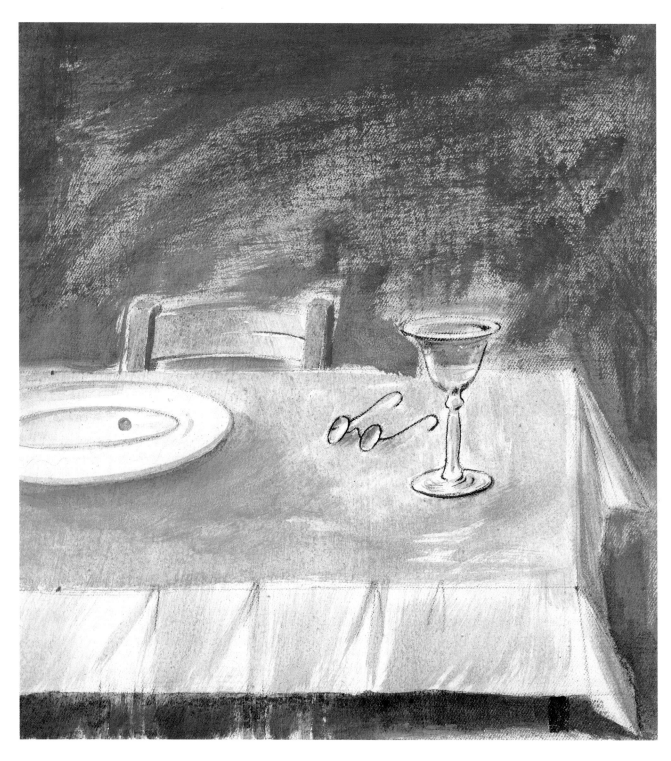

Next, I begin to work on the details of the individual objects. I give the back of the chair another glaze and emphasize the cast shadow and the contours of the glass. The shadow at its base makes the glass stand solidly on the table.

I soften the pink of the eyeglasses and repeat it in the tablecloth, but I wonder what I can do with the empty plate. I add a dot of color and decide that I'll figure out what to do with it later. Whenever I feel afraid of empty areas,

or even of an empty canvas, I dab on some color. This breaks the ice, and I can begin to paint.

I think about what to do with the red wall in the background. I like the rough texture of the canvas that shows through—after all, a wall isn't really smooth. The same holds true for the tablecloth—it's actually white, but it gives off a shimmer of blue. I go over it with white and then again with thin blue and a dry brush.

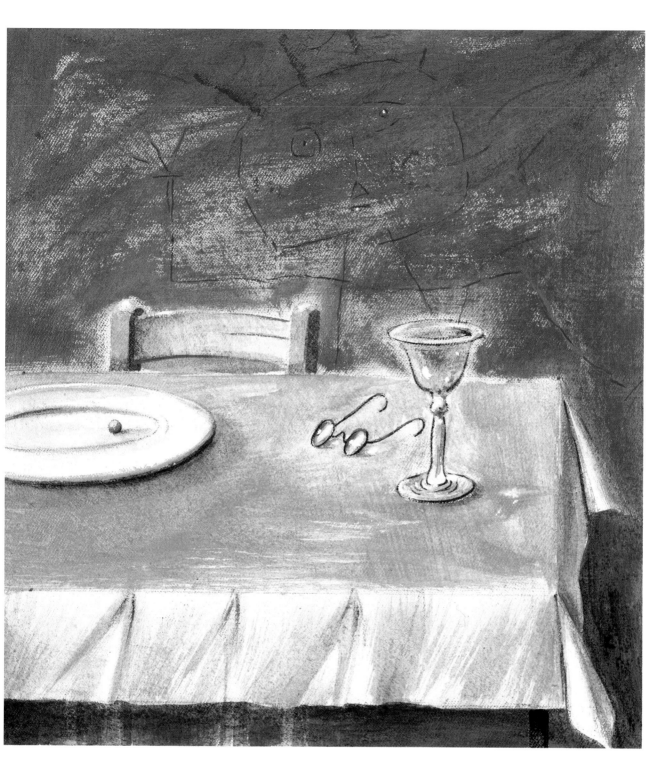

I wait until the end to work out details. At this stage, a painting gets its final appearance. First, I add more detail to the chair, and then I put in all the highlights and emphasize the shadows. The light in the glass is repeated on the tablecloth, and the dish stands out more. I apply a blue glaze over the tablecloth, emphasize the shadows of the folds, and make a pea out of the orange spot on the plate.

I look at the painting for a while, unable to decide what to do with the background. I want to retain the texture, but the area seems too empty. The table is set, and there's nobody around—why not put in some graffiti? Perhaps a child drew something very faintly on the wall. I'm as excited as a child myself—this normal still life now has an unusual twist.

Painting a Child's Chair and an Apple

with Brian Bagnall

I like unusual still lifes. I particularly like to make unusual still lifes out of everyday objects. Let's consider a round fruit or vegetable, such as an apple or a tomato. If you put it on a square table, you have the beginning of a composition of contrasts: circles against squares. What can you do with these simple, basic elements?

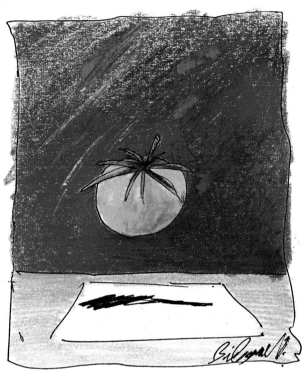

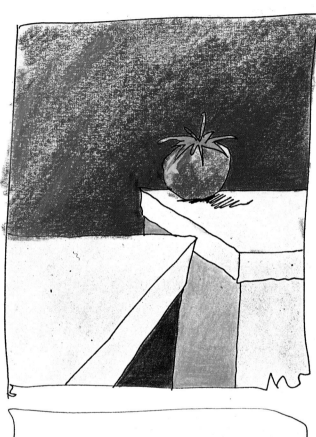

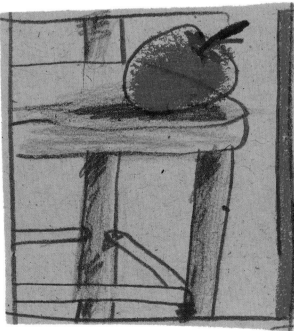

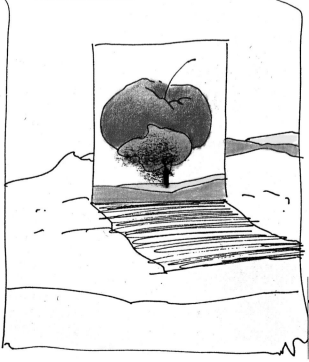

Think of all the square objects you can put something round on. A chair, a table, a piece of paper, a book, an envelope—the list is endless. I always make quite a few sketches just to get my imagination going. If I become especially creative, I can even put the apple in a landscape, as I do in the example at the left. What other possibilities can you think of?

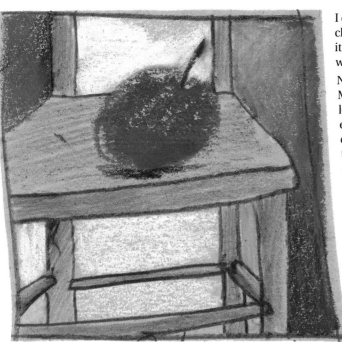

I don't have to be quite so surreal. Here I have a child's chair, which is normally occupied by dolls. I put an apple on it, and I notice that the fruit appears a lot larger than it would if I put it on a normal-size chair.

Next I look at this simple motif from all different angles. Many rectangles form in the spaces between the rungs and legs, surrounding the apple with geometric shapes. I am especially interested in these negative shapes. When I add color, I treat the individual areas as if they don't belong together. As you can see at the left, I give them different colors.

Then I get the idea to pull the room into my composition. I put the apple on the floor. Now the shapes of the floor and the walls, as well as those of the chair, are incorporated into the sketch. The apple remains the most realistic part of the picture, while the other shapes dissolve into areas of color. At last I have the basis for my oil painting.

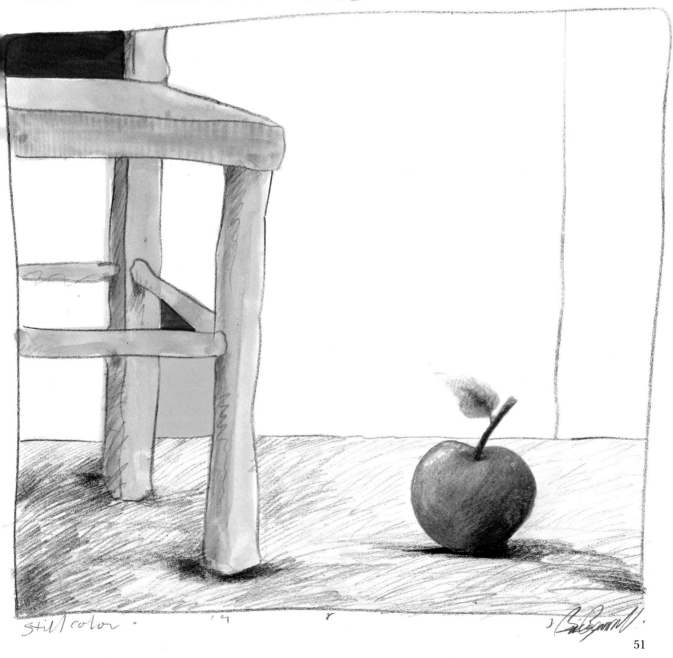

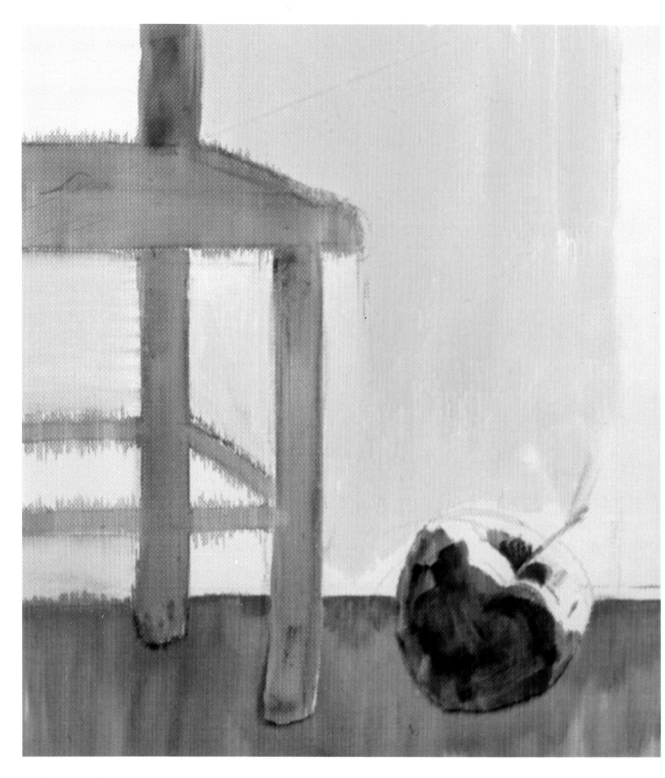

Colors used:

lemon yellow, cadmium yellow, cadmium orange, cadmium red, alizarin crimson, chromium oxide green, cobalt blue, ultramarine blue, fuchsia, yellow ochre, titanium white

Cézanne planned his compositions down to the smallest detail. He didn't leave anything to chance. I can understand this exactness because I hate nothing more than unintentional shapes in a painting. Spontaneity in technique can be exciting, but in a composition it bothers me.

In the beginning, I work with very thin paint. You can see that it even runs at the edges. These paint-runs do not present a problem, however, because I can paint over them later.

The colors I apply at this stage in a painting are not final. They're merely a base I can let shimmer through later if I want. At this time, I also figure out where I want the dark and light areas.

I concentrate a little more intently on the apple because it will be the most realistic part of my painting.

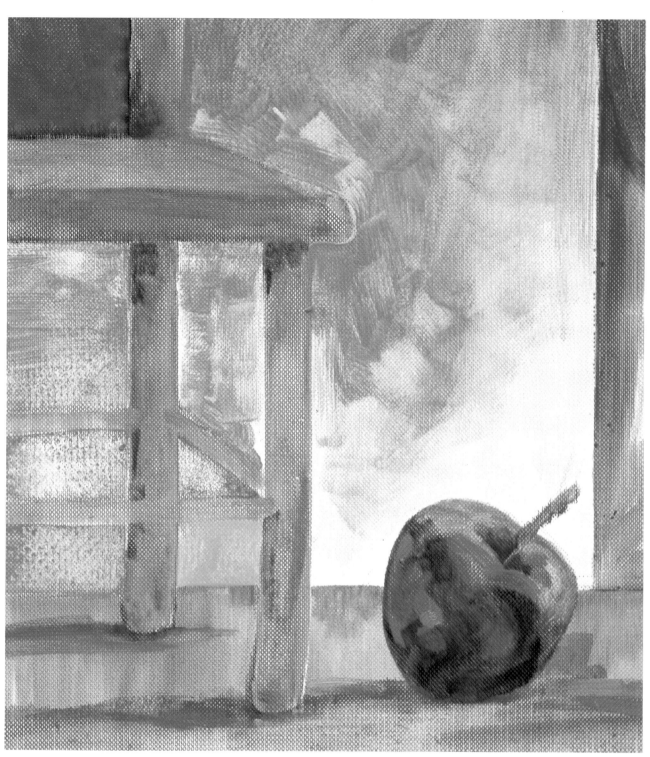

Black-and-white sketches, like the one at the left, can help you determine the areas of light and shadow in your motif. When you're sure about the values in a black-and-white sketch, it's easy to transfer them to the painting.

I paint over the wall with fuchsia, sometimes mixed with white, but I still allow the yellow to shimmer through. I give the chair a cast shadow to make it appear to stand solidly on the floor. I use orange, blue, and alizarin crimson to emphasize the areas of negative space, which I want as focal points.

I put in a distinct vertical area of ultramarine blue to give the composition balance.

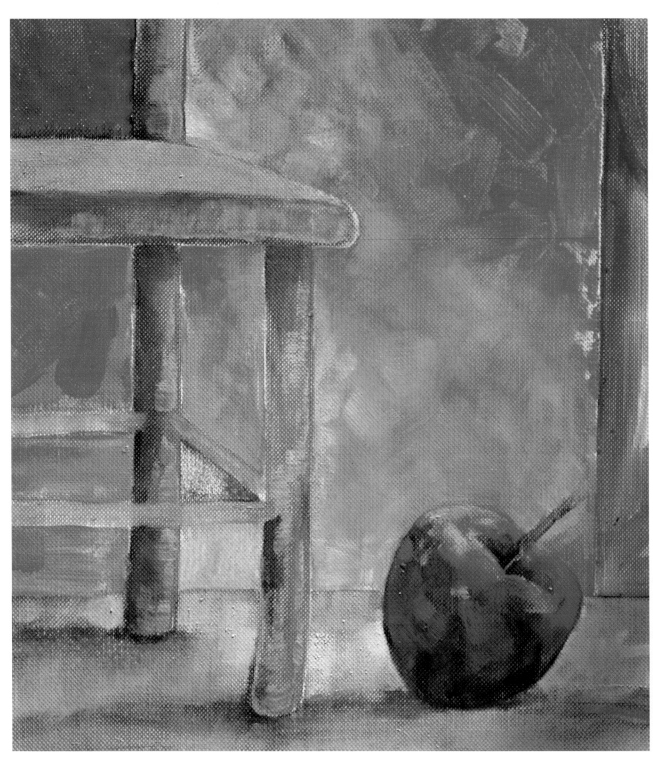

Now that the basic colors and composition are finalized, it is time for the details. A good rule is that all colors should be repeated somewhere in the painting, even if only in small flecks or dots. I work intensively on the floor, which is a base for everything that's important in the painting and reflects all the colors. I add more yellows to the chair to make it warmer and bring it closer into the foreground. The colorful negative spaces in the chair remind me of toys. Actually, they are

the only unusual elements in the painting.

There are two focal points here: the apple and the negative space in the upper left corner. The deep reds create an invisible diagonal line between the two points, and this diagonal makes the painting dynamic.

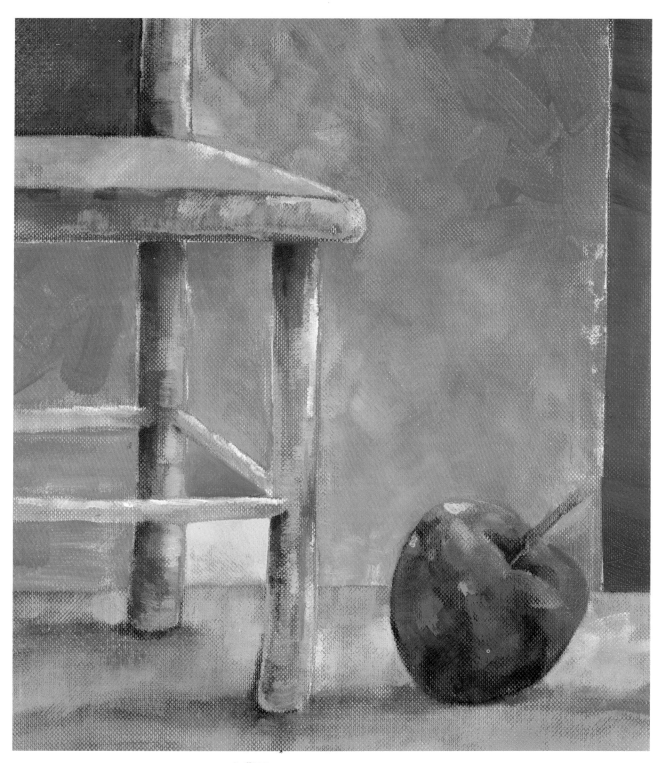

At this stage, all the areas become more distinct. I put in accents and repeat and change colors. The yellow in the square between the chair legs is repeated in the apple and the chair, and the green still shimmers through the base coat.

You can see that I'm influenced by famous artists. The green edges of the chair legs remind me of the blue edges in Van Gogh's *Chair and Pipe* (see page 27). The colorful areas are reminiscent

of the color blocks of Piet Mondrian (1872-1944), although his work is much more abstract.

This sketch shows once again the prominent parts of the composition that distinguish it from a mere reproduction of reality. Although my painting is finished, I'm still uncertain whether to emphasize the negative space in the upper left—or even paint it black. What do you think?

Exercises, Tips, and Ideas

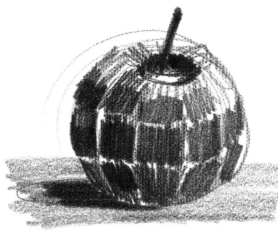

When you look at an oil painting, techniques involving thick brush strokes or generous areas of paint seem easy to duplicate. You can imagine being able to paint like that. Highly detailed work, in contrast, seems more difficult; the technique is too polished. Generally, however, you can learn all kinds of techniques. It's creativity that you can't learn.

The most important aspect of oil painting is the ability to observe. Some artists observe best with a pencil in hand, which enables them to capture an object. Consider an apple as an example. An artist can divide it into sections and study the light and dark values on all sides, then transfer the entire object—still black-and-white—to oils.

The ability to observe is very important if you want to paint from nature. Using a simple shape to learn how to give an object volume and depth can be an effective aid. Observing and drawing a simple form makes it easier to use the same technique at a later time with other shapes.

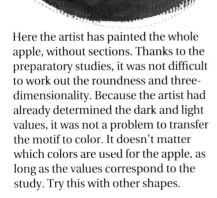

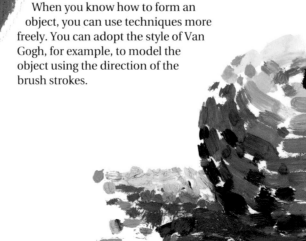

When you know how to form an object, you can use techniques more freely. You can adopt the style of Van Gogh, for example, to model the object using the direction of the brush strokes.

Here the artist has painted the whole apple, without sections. Thanks to the preparatory studies, it was not difficult to work out the roundness and three-dimensionality. Because the artist had already determined the dark and light values, it was not a problem to transfer the motif to color. It doesn't matter which colors are used for the apple, as long as the values correspond to the study. Try this with other shapes.

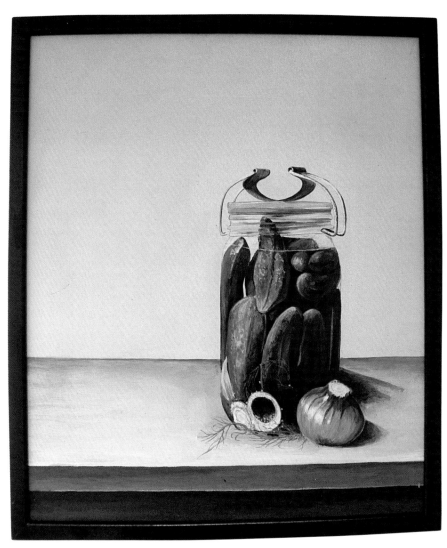

This naturalistic painting by Ronald Börner, a photorealist, should give you some ideas. In reaction to abstract art, movements developed in the 1960s that pursued realism to extremes. Börner, a police officer, took up this style of painting as a hobby. He either paints directly from nature or photographs his motif. The advantage of photos is that you can get the light just the way you want it and then keep it that way.

This jar of his aunt's homemade pickles seemed to him a work of art. He added the onion. Preliminary sketches and precise observation are essential to produce such a detailed painting.

"One day, several hairs fell out of my brush and stuck to my canvas. That's where I painted a bird's nest."
Picasso (1881–1973)

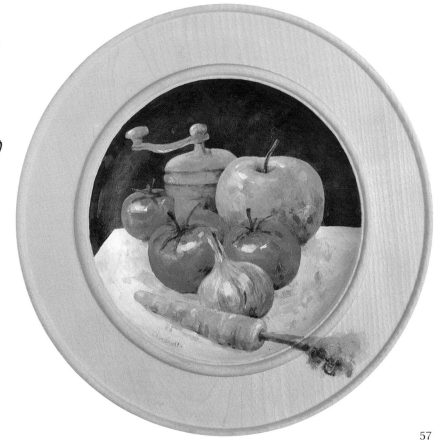

Always be open to new ideas and impressions, and don't be afraid to try things that seem unusual. For example, an artist found this wooden plate with fresh vegetables on it in the kitchen, took the plate, and used it as a painting surface. The vegetables are on it again—albeit in the form of oil paints—and as you can see, they're still fresh.

Stretching the Canvas

If you're not satisfied with prestretched canvases, you can do this job yourself. You can either use preprimed canvas or buy cotton or linen and prime it at home.

The frame that supports the canvas is made of pieces called stretchers. Small wooden wedges called corner keys fit into the corners of the frame and allow the canvas to be tightened as necessary (see illustration 1). If you don't have a workshop where you can saw exact angles, you should buy the stretchers and corner keys precut at an art supply store.

When the stretchers are assembled, lay them on the canvas and cut the canvas so that about two inches stick out around the frame. Be careful that the proper side of the stretchers is facing down.

Making sure the frame is parallel to the weave of the fabric, fold the canvas over one of the stretchers and tack or staple it to the stretcher's center, do the same on the opposite side, and then repeat the process on the other two sides of the frame (see illustration 2). Now you can stretch the material. Always work from the center outward, and work on alternate sides. Fold the corners neatly along the stretcher joint and nail them down (see illustration 3). Because the canvas shrinks somewhat after it's primed, don't stretch it too tightly; otherwise, it will tear at the corners.

You don't need the corner keys until the primer has dried. There are slots in the stretchers into which you can place the corner keys. Carefully insert two keys per corner (see illustration 4).

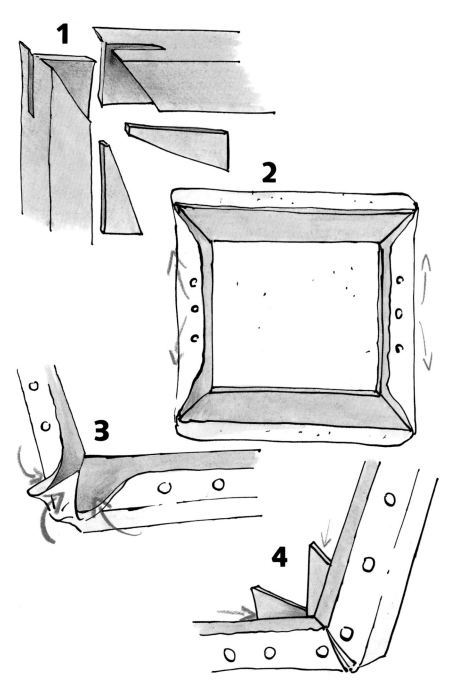

Easels

Easels are practical when they fulfill their purpose. If you like to paint outdoors, you should buy a light, folding easel. Don't be afraid to set it up in the store before you buy it—nothing is more annoying than an easel that wobbles or is difficult to set up. Studio easels take up a lot of room, but they're a safe place to leave a painting.

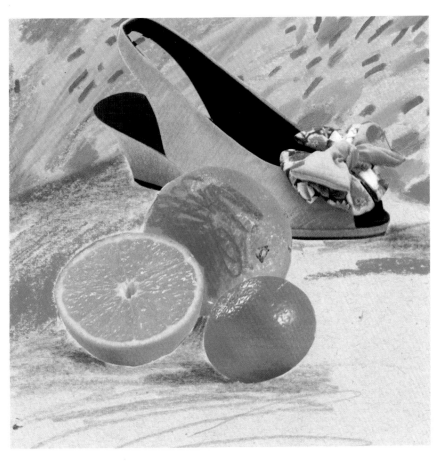

Playing Around

You can find inspiration everywhere. Some artists like to cut out illustrations from magazines and combine them into compositions. Over the years, they build up quite a file of pictures of objects to use in still lifes—for example, fruits and vegetables—and often collect unusual motifs as well.

In this example, the artist cut out a lady's shoe from an advertisement and threw a few oranges into the composition. Little collages like these are fun because the person making them can work spontaneously. They can also suggest some good ideas for oil paintings.

Frottage

The technique of frottage can result in interesting textures. The term comes from the French word *frotter*, meaning "to rub." First apply wet paint to a surface and lay a piece of nonabsorbent paper on top of it. Press the paper down gently and then lift it off to produce textures that you can continue to work with. The texture will vary, depending on the thickness of the paint.

Sometimes you can discover faces or entire landscapes in the effects created through frottage. What can you find in the examples below? Experiment a little. You can also scratch into the paints or draw into them with oil pastels—try out whatever you think is fun.

Here are examples of frottage with thin paint (yellow) and thick paint (layered red, yellow, and green). To the far right, you can see where I scratched into the thin frottage.

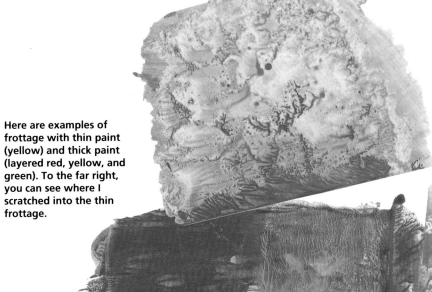

Motifs for Inspiration

Perhaps you'd like to continue painting still lifes on your own, but you can't find a suitable motif. Here are a few motifs to consider that are suitable for the techniques you've learned. How about an egg—but with a difference this time? You could make an interesting painting using delicate glazes and artistic shadows. You could repeat the yellow throughout the composition to tie it together.

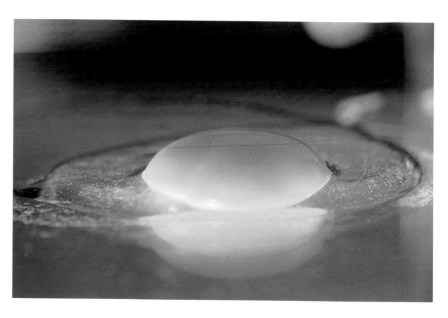

You can use the motif at the left to practice creating textures. Imagine painting the background in thick impasto as a contrast to the smooth vegetables. You could use both the palette knife and the brush. Try a few exaggerated sketches. Make the heavily structured background dominate in one, and exaggerate the vegetables in another.

For those who like realistic paintings, here is a neat, albeit difficult, motif: three apples that are distinguished only by color and shadow. You could use a fine brush, and the motif almost begs for glazes and gradations. Don't forget to use your imagination, however. You can change shapes and colors, move objects, and exaggerate reflections. Try to retain the plasticity of the apples, which is so effective in this photograph.

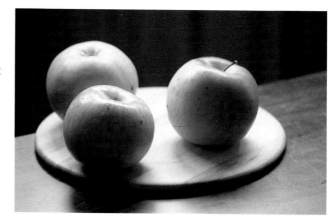

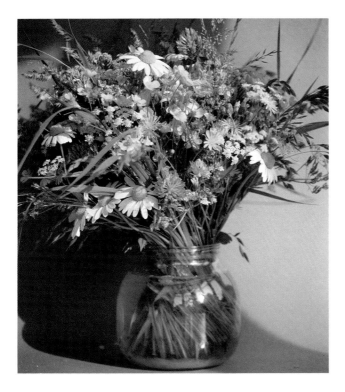

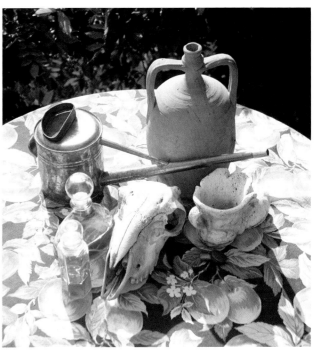

You could build up a painting of this picture with dots and stipples; stipples are small, short touches of paint. The individual flowers aren't as important as the overall impression of the bouquet—the feeling of summer meadows.

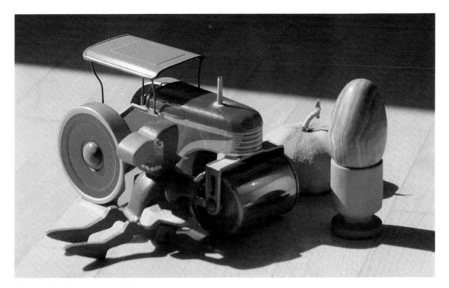

It's not easy to determine the focal point in the picture above. Some artists like to draw from photographs that aren't quite perfect, such as this one, because they force the artists to come up with a new and improved composition. You could make the pattern on the tablecloth more abstract. The colors, mixed with white, blend with the light hues of the objects. The round edge of the table is an interesting element in the composition and "contains" the other objects.

Above is a somewhat different still life: toys. Wood contrasted with metal and painted surfaces contrasted with unpainted surfaces force you to take a closer look. Try to bring out these contrasts in your painting. The shadow takes on a shape of its own, and the colors of the objects can be repeated in it. Even when you're painting "dead" objects, your painting can be lively.

You could paint a lively picture of this vegetable basket using fresh paint applied with a knife. Don't become distracted by details, and pay attention to the positive and negative spaces.

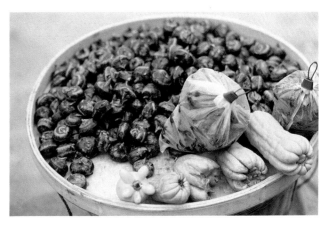

Glossary

abstraction
Simplifying an image into color, pattern, and form. The popularity of abstract art has spread since 1910.

cast shadow
The shadow created when an opaque object blocks a light source. The size and shape of the cast shadow are influenced by the position of the light source.

color, darkened
A color that has been mixed with black.

color, lightened
A color that has been mixed with white.

core shadow
The shadow found on an object. The core shadow is always lighter than the cast shadow and gives an object its shape and three-dimensionality.

cubism
An artistic movement that developed in Paris in the early twentieth century. The founders, Picasso and Braque, were influenced by Cézanne's ideas, in which natural forms were reduced to cubes, cylinders, and spheres. Although Cézanne used these geometric forms to help build compositions, the cubists turned them into an art form. The motif is depicted in its basic shapes, sometimes leading to complete abstraction.

dry-on-dry
A technique of applying unthinned paint on a dry base. Depending on the texture of the surface, the artist can achieve interesting effects.

glaze
A thin, transparent layer of paint applied over dry paint. When applying glazes with oil paints, however, do not apply lean paint (low in oil content) over fat paint (high in oil content). Placing lean paint over fat paint can result in cracks in the surface of the painting.

gradation
A progression of tones, shades, or colors. A gradation can be a transition from dark to light or vice versa. In a gradation from dark to light, increasing amounts of white are mixed with the hue.

impasto
A thick application of paint. In oil painting, this technique is used to apply thick layers of unthinned or lightly thinned paint with a sturdy brush or palette knife so that the paint stands up from the surface, resulting in an obvious texture.

intensity
The strength of a color. Intensity describes the degree to which a color is saturated with pigment.

negative space
The space that forms between objects in a motif or between the motif and the frame.

oil pastels
A medium made from a mixture of pigment, wax, oil, and animal fat. The resulting paste is molded into sticks. Oil pastels are soluble in turpentine and are water resistant.

plasticity
The effect of three-dimensionality. Just as the sculptor can model a three-dimensional figure, the painter can use techniques to achieve the illusion of space. *See also* **core shadow**.

pop art
A twentieth-century movement that depicts banal objects as works of art. Pop art developed in the 1950s and 1960s as a reaction against abstract expressionism. The pop artists saw artistic value in even the smallest objects of everyday life. They also parodied contemporary society as being inauthentic.

positive space
The areas formed by objects in a painting. Positive and negative spaces are always interrelated.

primary colors
Colors that cannot be obtained by mixing other colors. There are three primary colors: red, yellow, and blue.

surrealism
A late-nineteenth- and early-twentieth-century art movement that used the psychology of Freud to try to express the workings of the subconscious. The surrealists believed that dreams, drugs, and hypnosis could open the door to the subconscious, which they viewed as the true reality. Surrealism found its way into the visual arts through the paintings of Giorgio de Chirico and Max Ernst. Other well-known surrealists include Picasso, Klee, Dalí, Miró, and Magritte.

tonal value
The degree of darkness or lightness in a color, measured on a scale of gradations between black and white. Pure colors possess a value; for example, yellow is the lightest hue and violet is the darkest.

warm and cool colors
The two basic divisions of the color circle. The yellows, oranges, and reds are generally regarded as warm colors, and the greens, blues, and violets are considered to be cool. In the 12-color circle, red-orange is the warm pole and blue-green is the cool pole. The temperature of the colors between the two poles is relative to the colors they are contrasted with.

wet-in-wet
A technique of working with fresh paint on a wet surface. Working wet-in-wet allows the artist to achieve soft blends and delicate contours.

Index

A
abstraction, 26, 61

B
background, 28, 35, 42, 49
Bagnall, Ursula, 4
Bagnall, Brian, 5, 50
basic shapes, 18, 24
Börner, Ronald, 57
Braque, Georges, 26
brushes, 8, 10-13, 15, 38

C
canvas, 6-7, 9, 12, 38, 46, 58
cast shadow, 22, 25, 33
Cézanne, Paul, 7, 52
charcoal, 32, 39
closeness, 21
cloth, 15
collage, 31, 59
color, 6-7, 8, 12, 17, 23, 38
 cool, 12, 16, 27
 darkened, 16
 intensity, 17
 lightened, 16
 scheme, 43
 value, 16
 warm, 12, 16, 27, 54
colored pencil, 30
composition, 6-7, 19, 24, 28, 36, 39, 47, 50-55, 60
contrast, 28, 35, 39, 47
core shadow, 22
cotton canvas, 58
cropping, 46
cubism, 6-7

D
dark values, 32, 52, 56
depth, 20, 22, 24, 56
diagonal layout, 21, 24, 34, 41, 54
distance, 21
dry-on-dry, 15

E
easels, 9, 58
exaggerating, 18, 21, 24, 41
expression, 20
Eyck, Jan van, 6-7

F
felt markers, 30
flickering effect, 17
folds, 32-36, 49
frottage, 59

G
gesso, 10
glass, 44, 47
glazes, 14, 34, 47, 60
Gogh, Vincent van, 27, 55
gradations, 14, 60

H
highlights, 39, 43, 49
Hille, Astrid, 4
horizontal line, 20

I
impasto, 15, 60
Impressionism, 6-7
intensity, 17

K
Klapproth, Edeltraut, 5, 38
Kotter, Florentine, 5, 32

L
light, 22, 32, 39, 47, 49, 53
line, straight, 11
linseed oil, 14

M
Masonite, 10
mixing, 9, 11, 15, 28
Mondrian, Piet, 55
Morandi, Giorgio, 6-7, 28

N
Neuhaus, Uwe, 5, 44

O
oil pastels, 24, 30, 59
overlapping, 20, 40

P
paint set, 8
painting knife, 9, 11, 15, 61
painting medium, 8, 9, 10, 14, 38
painting surface, 10, 46
palette, 8, 11
palette knife, 9, 11, 13, 15
paper, colored, 30
pencil, 46, 56
photorealism, 57
Picasso, Pablo, 29
pop art, 6-7, 17
primary colors, 8, 12, 17
primer, 10, 46, 52, 58

S
scratching, 11, 26, 59
shadow, 22, 28, 32, 35, 37, 39, 44, 47, 53, 60
simplifying, 18, 36
sketches, 20, 24, 30, 32, 40, 44, 50, 53
sketching, 23, 29, 30, 39, 44
space
 distribution of, 20
 effect of, 39
 negative, 19, 24, 29, 51, 53, 61
 positive, 19, 24, 29, 51, 61
stretchers, 58

T
tension, 21, 24
texture, 10, 15, 26, 48, 59, 60
three-dimensionality, 15, 22, 24, 27, 39, 41, 47, 56
Titian, 6-7
tranquility, 21
turpentine, 8, 38

W
watercolor, 11, 14, 30
wet-in-wet, 15
white, 13, 47
wood, 46

Credits

Jan van Eyck, *Marriage of Giovanni Arnolfini and Giovanna Cenami* (page 6): The National Gallery, London.

Paul Cézanne, *Still Life with Apples and Oranges* (page 7): Museé Orsay, Paris, Hoffmann-Stiftung, Kunstmuseum Basel/Photo by Hans Hinz, Allschwil.

Vincent van Gogh, *Chair and Pipe* (page 27): The National Gallery, London.

Anne Vallayer-Coster, *The White Soup Bowl* (page 6)

Photo pages 8 and 9 by Ernst Fesseler

Copyright
Picasso: © VG Bild-Kunst, Bonn, 1993
Braque: © VG Bild-Kunst, Bonn, 1993

Oils — Still Life
Recommended Readings

Foster, Walter T. *Mixing Colors and Materials To Use.* How To Series. Laguna Hills, California: Walter Foster Publishing. 1989. #HT56. ISBN: 1-56010-046-X.

Palluth, William. *Painting In Oils.* Artist's Library Series. Laguna Hills, California: Walter Foster Publishing. 1984. #AL01. ISBN: 0-929261-05-4.

Powell, William F. *Color (And How To Use It).* Artist's Library Series. Laguna Hills, California: Walter Foster Publishing. 1984. #AL05. ISBN: 0-929261-05-4.

———. *Oil Painting Materials (And Their Uses).* Artist's Library Series. Laguna Hills, California: Walter Foster Publishing. 1990. #AL17. ISBN: 1-56010-056-7.